To Willo
From
Mom

MW00638994

IMAGES
of America
MARFA

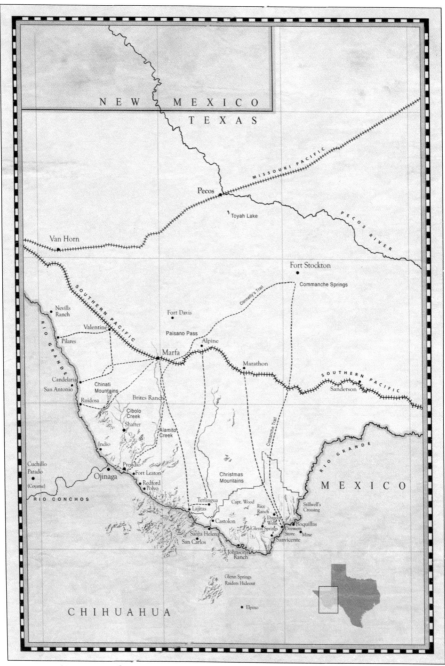

This is a map of Far West Texas. (Courtesy of John White.)

ON THE COVER: The Presidio County Courthouse is the visual icon for the town of Marfa, Texas. Designed in 1885 by architect J. H. Britton, it was built in the Second Empire style and was completed in 1886. It was one of the first major buildings, along with the jail, to be constructed after Marfa became the county seat. It has been through one major renovation in 2002. The courthouse remains a time-honored observer of the town, watching life in Marfa as it moves into a second century of growth and activity. (Courtesy of Marfa and Presidio County Museum.)

IMAGES
of America

MARFA

Louise S. O'Connor and
Cecilia Thompson, Ph.D.

ARCADIA
PUBLISHING

Published by Arcadia Publishing
Charleston SC, Chicago IL, Portsmouth NH, San Francisco CA

Printed in the United States of America

Library of Congress Catalog Card Number: 2008932136

For all general information contact Arcadia Publishing at:
Telephone 843-853-2070
Fax 843-853-0044
E-mail sales@arcadiapublishing.com
For customer service and orders:
Toll-Free 1-888-313-2665

Visit us on the Internet at www.arcadiapublishing.com

*To all who visually recorded the history of Marfa, whether by casual
snapshot or by professional documentation. Both methods preserve
personal and community history that is of great importance to all of us.*

CONTENTS

ACKNOWLEDGMENTS

The authors, Cecilia Thompson and Louise S. O'Connor, are incredibly grateful to Leah Bianchi and the rest of the staff of Wexford Publishing, Victoria, Texas; Vicente Celis, Ballroom Marfa, Marfa, Texas; the Marfa Public Library; the Marfa and Presidio County Museum; the Shannon Collection; the Evans Collection, the Brite/White Collection; the Lloyd MacDonald Collection; Armando Vasquez/Casa Piedra; Joe Cabezuela and the Blackwell School; Cibolo Creek Ranch; Georgie Lee Kahl; the Bogel/Hubbard Collection; *The History of Marfa and Presidio County*, Vol. I and II, by Cecilia Thompson; *The History of the Marfa National Bank*, by Lee Glascock Bennett; the *Big Bend Sentinel*; the Glider Association; and most of all, our capable and hard-working research assistant, editor, and advisor Ellie Meyer-Madrid, Marfa, Texas.

INTRODUCTION

The entire Chihuahuan Desert, which includes what is now Presidio County, was called *el desplobado*, "the uninhabited," by the Spanish *entradas*. The region, a mountainous desert area, became a mecca for cattlemen in search of free range in the mid-19th century.

The construction of the Galveston, Harrisburg, and San Antonio Railroad, which crossed the area now known as the Marfa Plateau, resulted in the establishment of a water stop called Marfa in 1883. Legend has it that the town was named by an engineer's wife who was traveling with him during the construction of the railroad to the Trans-Pecos area of Texas. It seems she was reading *The Brothers Karamazov*, by the Russian writer Fyodor Dostoyevsky, and named the fledgling town after a character in the book. As she passed through the small towns dotting the rail lines, she named many of them based on literary references. Longfellow and Dryden are two other examples. As for Marfa, what began as a boxcar depot developed into a busy shipping point for cattle, cotton, and ore. Because of its location and early commercial successes, Marfa became a center of activity for the ranching community, whose members contributed to a thriving social and cultural situation.

Before the area was settled by Americans, Apache tribes had run rampant throughout the region. Fort Davis was originally established in 1854, with a brief hiatus during the Civil War, to protect westward-bound travelers. The fort reopened in 1867, manned by Buffalo Soldiers, but was finally deactivated in 1891. There were no armed forces in the area from that point until the Mexican Revolution erupted in 1910, at which time military outposts were established along the Rio Grande.

These border outposts were served by what began as Camp Albert, later named Camp Marfa, located in Marfa. The military installation was designated as a permanent base and renamed Fort D. A. Russell in 1930. Once the active border upheavals were subdued, the U.S. Border Patrol became a major factor in controlling immigration and smuggling. The Border Patrol was first assigned to Marfa, where the sector headquarters are presently located, in 1924.

The early 1920s brought commercial, social, and cultural development. The prize-winning Highland Hereford was brought to prominence by the Highland Hereford Breeder's Association. The community's growing prosperity was indicated by the construction of a number of homes that are now points of historic interest. Schools, churches, and entertainment flourished within the little cow town.

With the outbreak of World War II, Marfa again became the center of military activity, not only because of the presence of Fort D. A. Russell, but also because of the establishment of the Marfa Army Air Field, located 10 miles east of town. Wartime activity brought a growing population, as well as additions to the commercial area along Highland Avenue. Throughout World War II, Marfa, like many small communities affected by the military, grew and prospered.

At the close of World War II, both Fort D. A. Russell and the Marfa Army Air Field were abandoned. Marfa was beset by a sudden loss of population and financial support. In addition,

the 1950s brought a devastating drought and recession to the area. Consequently, the ranching industry suffered losses from which it has never fully recovered.

Nevertheless, Marfa's most abundant and enduring natural resources, the land and the sky, are responsible for a unique array of activities that have had economic repercussions for the town. Discovery of the landscape surrounding Marfa by movie impresarios brought unexpected and dramatic recognition of the area by the film industry. George Stevens's production of *Giant* opened the region up to numerous other film projects, including *Andromeda Strain, Fandango, The High Lonesome*, and more recently, *No Country For Old Men* and *There Will Be Blood*. The mysterious Marfa Lights are recognized worldwide as a natural phenomenon attracting hundreds of scientists, tourists, and the curious each year. The area was selected as the site for an international soaring competition in 1970 due to the unique thermal conditions in the western sky. The thermals continue to attract soaring enthusiasts to the region.

The world-renowned artist Donald Judd also discovered the beauty of the area in the 1970s. The Dia Art Foundation of Houston subsequently provided housing for his work at the former Fort D. A. Russell, now the Chinati Foundation. Attracted by the congenial atmosphere created by the Chinati Foundation, artists began to establish homes, studios, and galleries in Marfa in the 1990s. At the present time, the little town is recognized internationally as a cutting-edge art community.

One

SETTLING THE FRONTIER
1857–1900

Milton Faver established his headquarters, El Fortin del Cibolo, south of present-day Marfa in 1857. At this time, Mexican immigrants who lived along the Rio Grande and the Buffalo Soldiers who protected the settlers from Native American depredations at Fort Davis were the principal inhabitants of this desert region. The economic potential of the area began to be recognized by Americans after the Civil War.

The cattle brought in by the early settlers consisted of a hardy but scruffy breed that in time became inadequate to the standards of the burgeoning beef cattle industry. The early West Texas ranchers first brought in the Durham Shorthorn and then began crossbreeding the Durham Shorthorn and the purebred English Hereford. This breeding produced the famous Highland Hereford, a breed of cattle that thrived on the High Chihuahuan Desert.

Early on, sending and receiving supplies was a great problem for people living in the West. Eventually, the north-south route widened along the Chihuahua Trail. This road was based on a Native American trail of earlier years. The arrival of the Galveston, Harrisburg, and San Antonio Railroad at Marfa in 1883 provided a means for area ranchers to maintain a steady supply of goods from elsewhere, as well as a way to market cattle.

These early ranchers must have lived through adventures people in the modern world can only imagine. The West was a dangerous and trying place to live in 150 years ago.

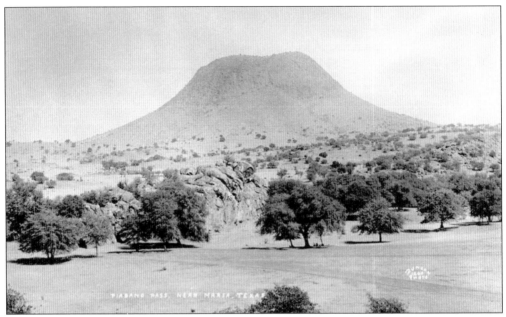

A young Robert Ellison accompanied his father, Col. J. R. Ellison, on one of the first cattle drives through the Paisano Pass and onto the Marfa range in March of 1883. Paisano Pass is the highest point on the Southern Pacific Railroad, now the Union Pacific. (Courtesy of Duncan Collection, Marfa and Presidio County Museum.)

The Chinati ("blackbird" in a local Native American dialect) Mountain Range has been described in the Handbook of Texas Online as "a series of terraced and dissected mesas cut by rugged canyons." The Chinatis lie between Pinto Canyon to the northwest and Cibolo Creek to the south. Chinati Peak is the highest point in the range, with an elevation of 7,728 feet. In the 1880s, mining developed in the area just south and east of the range when John Spencer discovered silver-bearing ore near Shafter. (Photograph by Vicente Celis.)

Milton (Don Melitone) Faver was the first large-scale cattleman to settle in the Trans-Pecos area when he established his headquarters at El Fortin del Cibolo in 1857. He prospered against impossible odds and became the first cattle baron west of the Pecos. (Courtesy of Cibolo Creek Ranch.)

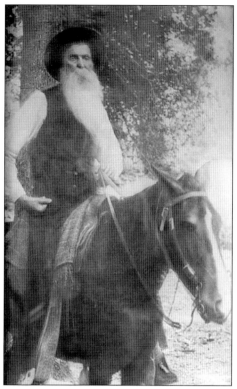

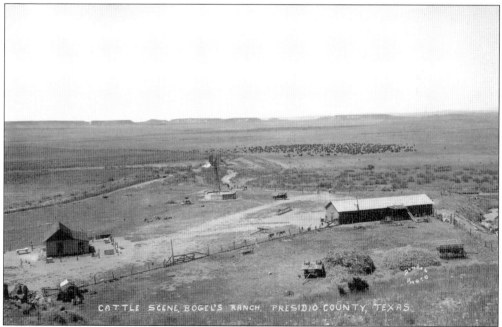

The W. W. Bogel Ranch was established around 1888–1890. The family moved from Alamito Creek to nearby San Esteban, then on to Marfa in 1892. Both W. W. and his wife, Sarah, entered into the social and civic life of Marfa and exerted great influence for its betterment. (Courtesy of Duncan Collection, Marfa and Presidio County Museum.)

W. F. Mitchell brought his entire family to Marfa in 1885, taking up periodic residence at Antelope Springs. Sons Tom and Arthur helped move 900 head of cattle from central Texas, arriving at the ranch just outside Marfa on September 6, 1885. (Courtesy of Junior Historian Files, Marfa Public Library.)

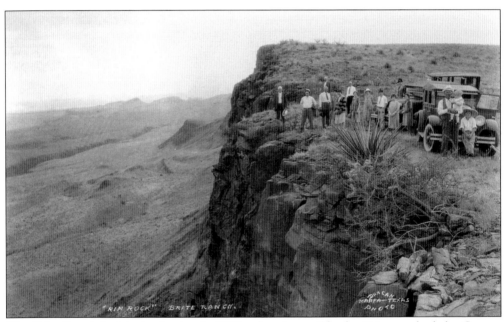

The Brite Ranch had its beginning in 1885, when Lucas Charles Brite reached the Capote Mountains at the end of a long trail. Having driven his first cattle from central Texas, Brite became one of the largest cattle breeders in Presidio County. This is a photograph of the Rim Rock on the Brite Ranch near Lucas Brite's first camp. The people in the image are unidentified. (Photograph by Frank Duncan; courtesy of Brite/White Collection.)

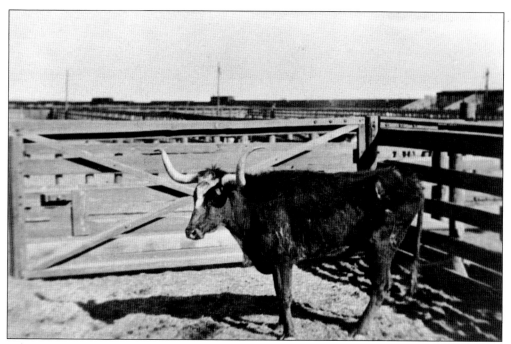

Why was it necessary to create the Highland Hereford? Is it any wonder the ranchers thought a change might be wise? Take a look at this rough character. This must have been what inspired the ranchers to first mix the Longhorn with the Durham Shorthorns from England. This crossbreeding began quite early, around 1885, but it was not until 1887, when the Hereford was introduced, that West Texas cattlemen came to national prominence with this more refined breed of feeder cattle. (Courtesy of Marfa and Presidio County Museum.)

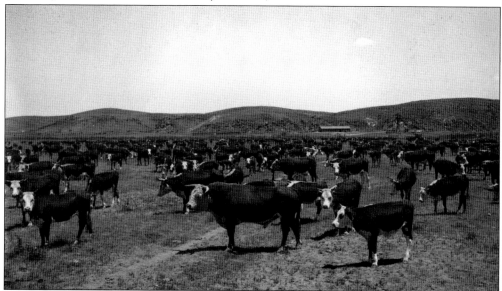

Hereford feeder stock pastured near the Brite family home in Marfa provides a good example of cattle that were produced to the stringent standards of the Highland Hereford Breeders Association. Specifications for the breed include the characteristic reddish-brown color and white face and chest. (Courtesy of Duncan Collection, Marfa and Presidio County Museum.)

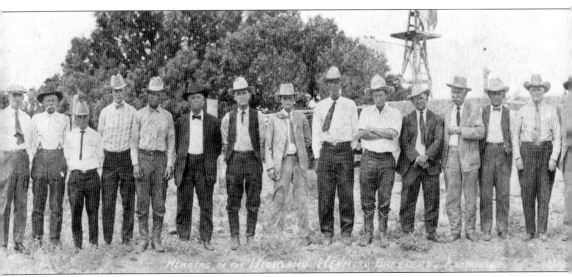

As the Highland Hereford became the accepted standard for West Texas cattle, the establishment of the Highland Hereford Breeders Association became necessary. All who were around for the heyday of this organization tell stories of the importance of the association to the breed and to ranching in West Texas. This photograph was taken in 1919 at an association meeting on the

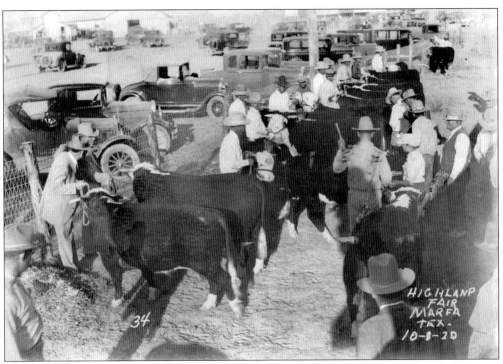

The Highland Fair often made front-page news in the local paper and attracted cattle buyers to Marfa from all over the country to see the current show of Highland Herefords. (Courtesy of Marfa and Presidio County Museum.)

Frank Arthur Mitchell's Nopal Ranch. It has been said that the members of this association were responsible for establishing Presidio County as a viable commercial and ranching center. (Courtesy of Duncan Collection, Marfa and Presidio County Museum.)

Early homesteaders contributed greatly to the initial settlement of Far West Texas rangeland. As time passed, the more prosperous ranchers often bought the smaller ranches, thereby amassing greater and greater tracts of valuable land. (Courtesy of Junior Historian Files, Marfa Public Library.)

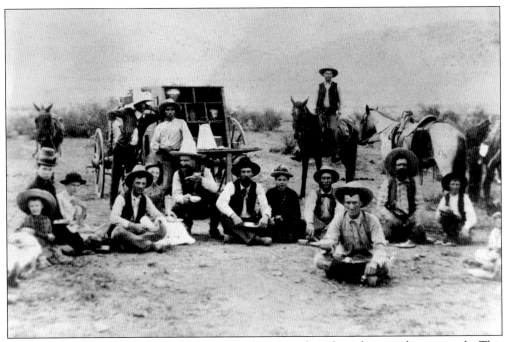

Cowhands and ranchers gather around the chuck wagon after a long day rounding up cattle. This group is unidentified, but note the women with the cow crowd. Often the wives and children of the ranchers and foremen were invited to the camp as guests during roundup time. (Courtesy of Junior Historian Files, Marfa Public Library.)

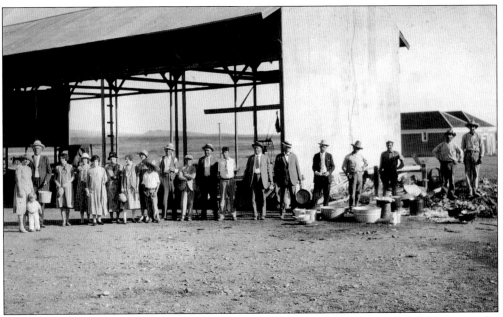

Family and friends gather at the Brite Ranch for a community barbeque intended to observe the raising of silos on the ranch. The silos remained unfilled, as the land was unable to support a farming enterprise of that proportion. (Courtesy of Brite Collection.)

Two

LIFE IN A FRONTIER TOWN
1883–1920

There was virtually nothing there when the railroad created a water stop in 1883 in what is now Marfa, Texas. Early Marfa consisted of a Chinese restaurant, a saloon, and a railroad boxcar that served as a depot. From this humble origin, early settlers would see Marfa develop into a thriving town with schools and lucrative businesses. The courthouse and jail were completed in 1886, after Marfa was established as the Presidio County seat.

Before the arrival of the railroad, ranchers in Presidio County drove their cattle to market. After the railroad was established, the cattle were shipped by freight car. At this time, trade and commerce grew, and the ranching industry continued to develop. Many Hispanics were employed by the ranchers, who readily admitted that they could not have made it without this help.

Women were as instrumental in settling Far West Texas as the men. The ranchers married socially adept women who established the cultural side of Marfa. These women expanded the concept of social development and allied with culture of all kinds. When the school was established, ranchers and their families started moving to town. This move substantially changed ranching and ranch life.

It was all a valiant and successful attempt to tame the frontier. Marfa had become one of the leading West Texas towns.

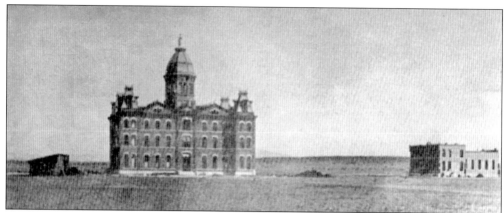

In 1886, J. H. Britton was awarded the construction contract for the Presidio County Courthouse, and Alfred Giles was given the construction contract for the jail. Bald open prairie surrounded these structures. They were magnificent in their time, as they are still. Around them a town grew and prospered. A grand ball was held on January 1, 1887, to celebrate the completion of the courthouse and jail. According to the written record, this was the first gala ever in the new county seat, which was less than two years old. (Courtesy of Marfa and Presidio County Museum.)

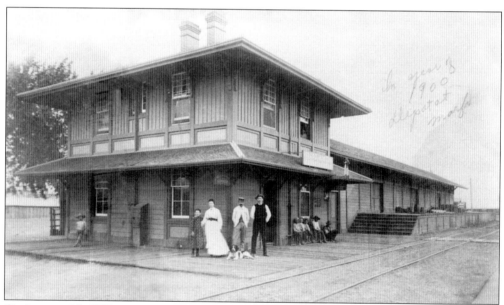

On January 16, 1883, construction on the Galveston, Harrisburg, and San Antonio Railroad reached what is now Marfa. In 1885, the Southern Pacific, the new owner of the railroad, built this two-story depot for freight and passengers. The upper story was for the stationmaster and his family. In 1904, an arsonist set fire to the building to cover his theft of a payroll being sent to the silver mine in Shafter. Local lore has it that after the fire, a large shipment of potatoes was discovered in the depot that had been adequately cooked and was subsequently enjoyed by the community. (Courtesy of Marfa and Presidio County Museum.)

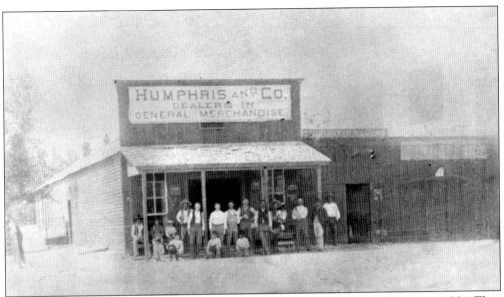

John "Don Juan" Humphris, Charles Murphy, and James Walker came to the area in 1884. They formed a partnership raising sheep and purchased the only store in Marfa at the time, a combined residence and mercantile housed in a tent owned by S. F. Wiles. After the purchase, it was known as Humphris and Company, and later, it was Murphy and Walker. This photograph was taken around 1896. (Courtesy of Junior Historian Files, Marfa Public Library.)

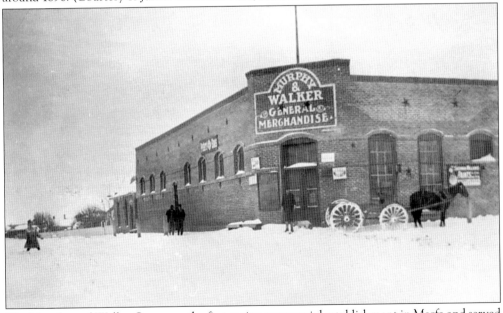

The Murphy and Walker Store was the first major commercial establishment in Marfa and served as a social and cultural institution as well. During its history, the facility housed many businesses, including a private bank, the Alta Vista Hotel, the Marfa State Bank, a stagecoach stop, a telegraph office, a real estate office, and the Crews Hotel. The establishment, which employed a number of bachelorette girls, extended credit to the ranchers and farmers from season to season until drought and the Depression eventually bankrupted it. (Courtesy of Junior Historian Files, Marfa Public Library.)

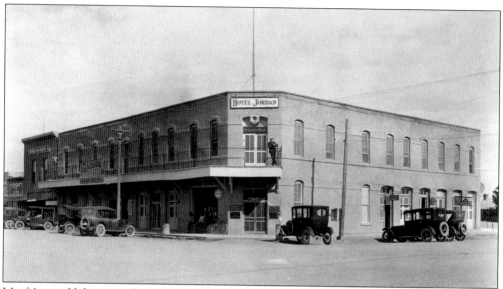

Marfa's social life centered on its hotels for many years. Ranch families who made their annual or semiannual trips into town made the hotels their headquarters. Memories of the old St. George Hotel, long regarded as the leading hotel in town, are still vivid in the minds of some pioneer family descendants. The hotel, first known as the Jordan Hotel, was erected in 1886 and witnessed the growth of Marfa from a small village to a prosperous frontier town. (Courtesy of Junior Historian Files, Marfa Public Library.)

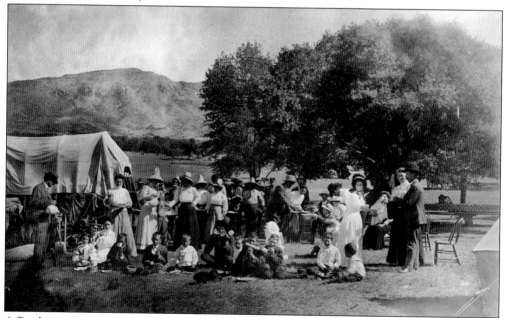

A Presbyterian minister, Rev. W. B. Bloys, arrived in Fort Davis in 1888 and made his rounds to cow camps and ranch homes. Mrs. Exa Means suggested that there should be a place for ranchers, cowhands, and townspeople to meet and worship together. The place, date, and arrangements were made, and the Bloys Camp Meeting opened in 1890. The camp, located in Skillman's Grove near Fort Davis, continues today to serve the entire Marfa area and beyond. (Courtesy of Mrs. Georgie Lee Kahl.)

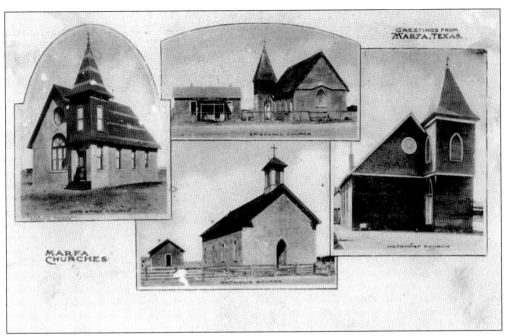

Marfa churches were the center of religious life in the fledgling town. The first was San Pablo, a nondenominational church started by Mary Walker Humphris. (Both courtesy of Junior Historian Files, Marfa Public Library.)

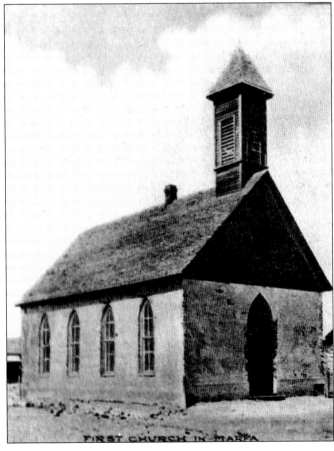

Rev. R. L. Millican was the moving force behind the Paisano Baptist Encampment, which was firmly established in 1921 when title to 1,000 acres of land between Marfa and Alpine, on which the encampment is still located, was received from Alfred S. Gage. This photograph taken at an encampment meeting features, from left to right, Rev. R. L. Millican and Crawford and Burton Mitchell. Note the expressions on the faces of the Mitchells. (Courtesy of Marfa and Presidio County Museum.)

The first public school was organized in Marfa in 1885. The school was taught by Kate Barnhart and was housed in a one-room adobe building. (Photograph by J. D. Walker; courtesy of Junior Historian Files, Marfa Public Library.)

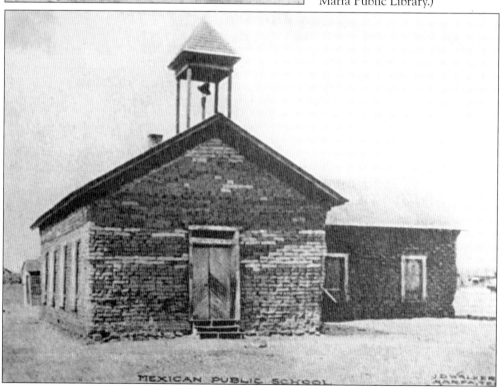

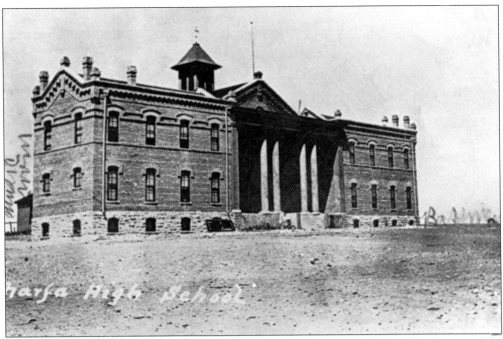

Marfa did not have a high school until 1900. The school building was erected on the site of the present high school and was an elaborate multistoried brick structure. It had four classrooms on the first floor and two on the second. The building was razed in the summer of 1925 after a fire damaged the structure. The present high school opened its doors in November of the same year. (Courtesy of Marfa and Presidio County Museum.)

One of the most revered landmarks in Marfa and West Texas was Tula's Restaurant, forerunner of the Borunda Café. It was the first Tex-Mex restaurant in Texas. Established in 1887 by Tula Borunda Gutierrez, the restaurant was originally located on Dean and El Paso Streets. The menu then consisted of steak, eggs, beans, and potatoes, as well as enchiladas that were served once a week. The café fed mostly railroad men. The restaurant later moved with Carolina Borunda, Tula's niece, to a location one block further south at the corner of Dean Street and Highway 90. (Courtesy of Junior Historian Files, Marfa Public Library.)

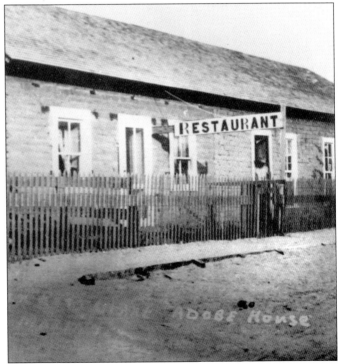

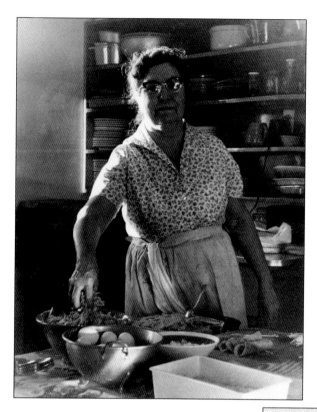

Carolina Borunda Humphris, the daughter of Tula's sister, kept the restaurant open to celebrate its 100th anniversary in 1987. On almost any night until it closed, descendants of area pioneer families could be seen eating at the Old Borunda. Carolina kept a club over the door to enforce strict behavior codes among the guests. (Courtesy of Junior Historian Files, Marfa Public Library.)

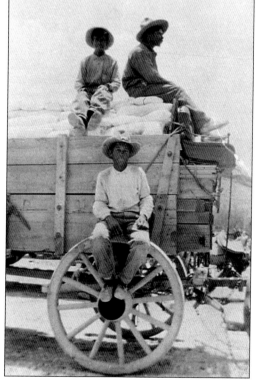

Around the end of the 19th century, ore wagons from Shafter and Terlingua carried silver bullion and flasks of quicksilver. Other minerals that were hauled to Marfa for shipping were secondary cargo. (Courtesy of Junior Historian Files, Marfa Public Library.)

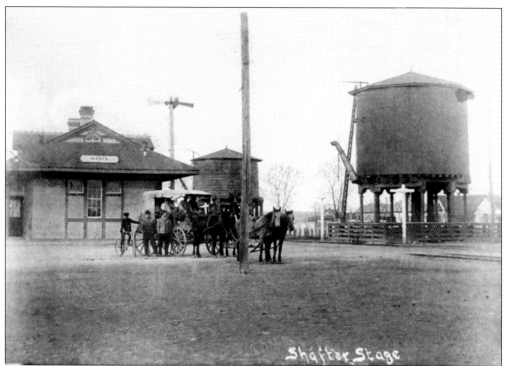

By 1890, the stage line ran regularly between Marfa and Shafter. Select items sent by stagecoach from Marfa to Shafter during December of 1890 represent a curious assortment of goods and people: one tub of butter; one passenger, $5; two boxes of oranges; one rooster; Mrs. Faver, one trunk, 130 pounds, $3; and one "Gal" for Gabino. James A. Shannon purchased the stage line and mail outfit from Dave Aiken in February of 1908. Shannon continued to work as mill foreman at Shafter, and his older sons operated the stage. (Courtesy of Shannon Collection and Junior Historian Files, Marfa Public Library.)

The town's early stock pens were located in the area west of the depot. The sale of cattle was essential to the economy of the area. Most of the cattle were shipped to San Antonio at that time. An elderly citizen recounted in 1971 "a vivid recollection of the first circus to visit Marfa in 1903. School was dismissed and the children trooped to the old stock pens to see the elephants come down the chutes." (Photograph by J. D. Walker; courtesy of Junior Historian Files, Marfa Public Library.)

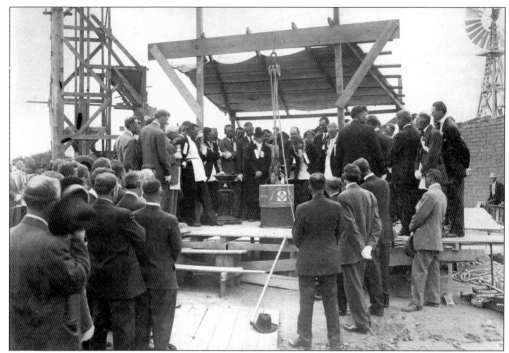

It had been almost a year since the county seat had been moved to Marfa, but the Masonic Lodge was repeatedly being moved back and forth between Marfa and Fort Davis. After a compromise was finally reached between the competing communities, the lodge remained in Marfa, where a new hall was built. In the meantime, it appears the meetings were held outside. (Courtesy of Bogel/Hubbard Collection.)

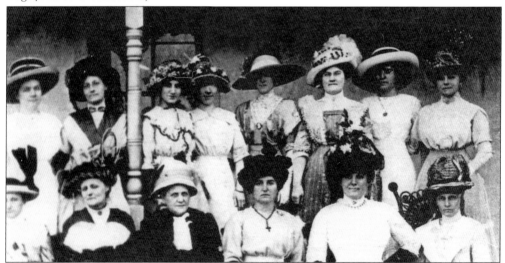

The Marfa Ladies History Club first met at the home of Mrs. Sarah Newton Bogel on September 7, 1899. Women were clearly important in shaping the cultural situation from an early date in the town's history. Several of the ladies were college graduates, and all of them were ambitious to improve conditions and to create cultural interests for themselves, their children, and for the town of Marfa. There were 17 charter members. (Courtesy of Junior Historian Files, Marfa Public Library and the Marfa History Club.)

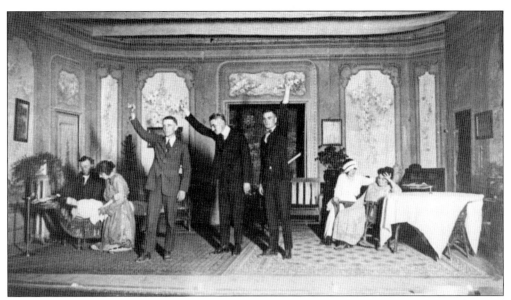

For a number of years, Marfa had the only theater between El Paso and San Antonio. The "Old Opera House," or "Town Hall" as it was called, had a long and colorful history. It was organized in 1905 with W. F. Mitchell as president. It was used for every conceivable type of entertainment, including country dances, banquets, traveling vaudeville shows, local drama, the Chautauqua, baccalaureate and graduation exercises, a skating rink, recitals, concerts, revival meetings, and movies. Silent movies began to be shown in 1917. Talkies arrived in 1929, when it was known as the Palace Theater. (Courtesy of Junior Historian Files, Marfa Public Library.)

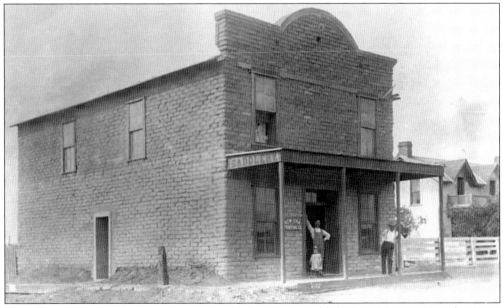

The first newspaper printed in Marfa was the *New Era*, established on May 20, 1886, by C. M. Jennings. He bought up-to-date equipment and also did job printing. O. L. Niccolls bought the paper in 1890 and housed it in a building on El Paso Street on the block where Segura's Furniture Store once was. By 1908, the *New Era* was sold to cattleman L. C. Brite, who hired a manager to operate it. (Courtesy of Junior Historian Files, Marfa Public Library.)

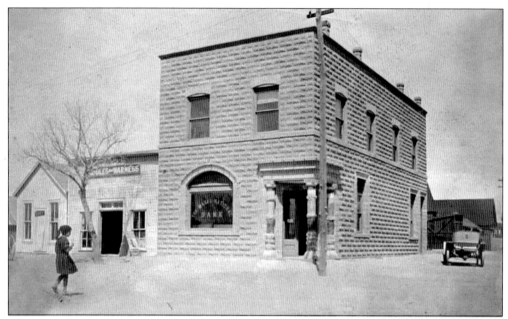

The Marfa National Bank was established in 1907. By 1908, it had located in a new building at the corner of North Highland and West Oak Streets in the heart of the business section of town. The bank also contained the Marfa Telephone Exchange and a social club, both on the second floor. The club was set aside two days a week for the ladies. (Courtesy of Junior Historian Files, Marfa Public Library.)

A major enterprise was organized in 1907, when the Marfa Manufacturing Company was bought by Gus Elmendorf with T. C. Mitchell as partner. It became the largest industrial concern in the Big Bend and dispensed many services to the community. (Courtesy of Marfa and Presidio County Museum.)

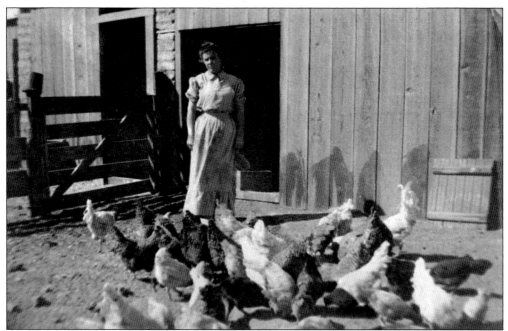

Not every woman in Marfa was able to be a member of the Marfa Ladies History Club. The life of a pioneer woman was not easy. Even in town, she had to raise most of her own food and do the usual chores that most women did in those days—churn, sell butter, cook, wash, and raise children to name a few daily tasks. (Courtesy of Marfa and Presidio County Museum.)

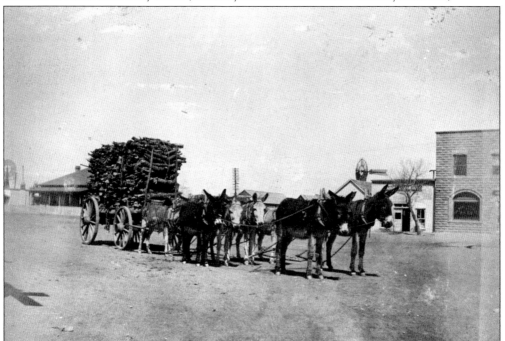

Despite vast improvements in the business community, many services remained somewhat primitive. Here a firewood wagon led by a donkey team makes its rounds. The Marfa National Bank is on the right. (Courtesy of Junior Historian Files, Marfa Public Library.)

After a mail hack was substituted for the stagecoach, Charlie and Kehoe Shannon had one fleeting encounter with would-be bandits. While carrying the payroll to Shafter, the boys passed several men on horseback about 8 miles out of Marfa. As the riders approached, the two mail carriers drew down on the bandits who immediately fled. A young Will Shannon, brother to Charlie and Kehoe, is seen in this photograph. (Courtesy of Shannon Collection and Junior Historian Files, Marfa Public Library.)

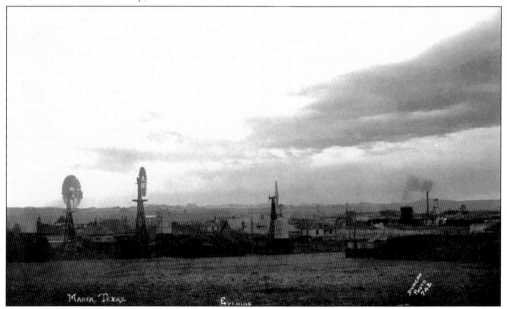

L. C. Brite often commented upon arriving home from the ranch that he could see the windmills from the edge of town. Marfa was filled with windmills before the days of a city water system. (Courtesy of Duncan Collection, Marfa and Presidio County Museum.)

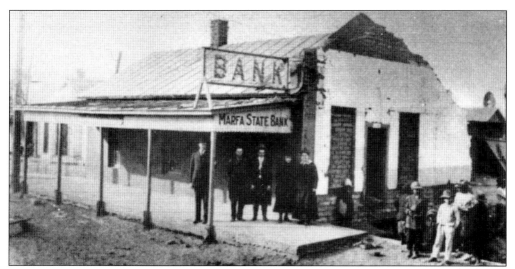

The Marfa State Bank, with T. M. Wilson as president, opened to the public on January 22, 1910, in a small adobe house south of Murphy and Walker. It soon moved to a larger building in the heart of the business district on El Paso Street and later occupied a corner space in Murphy and Walker itself. The significance of having a state bank in Marfa was that it could issue loans on real estate, which the Marfa National Bank was prohibited from doing. (Courtesy of Junior Historian Files, Marfa Public Library.)

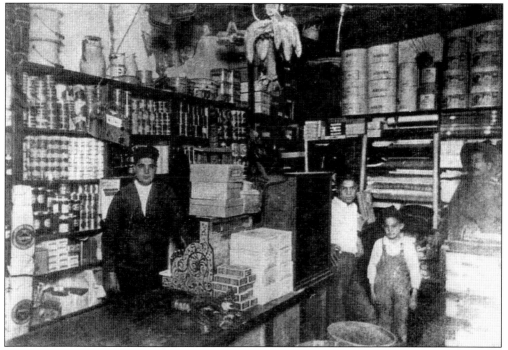

Rumaldo Segura was a merchant of note who opened a general store in Marfa in 1914 with two partners. He built up a solid business and was later joined by his sons in the store called R. Segura and Sons. Rumaldo Segura and his wife had 14 children, all of whom became prominent citizens in the community. Rumaldo Segura died in 1960. (Courtesy of Junior Historian Files, Marfa Public Library.)

Women of Marfa were considered the best dressed in the area. The owner of Milady Dress Shop, Mrs. Mary Howard, known as "Mary Hat," made two trips a year to New York City to buy merchandise. (Courtesy of Junior Historian Files, Marfa Public Library.)

Note the requisite palms of the era. The Busy Bee Store, owned by Mr. and Mrs. Jack Shipman, was decorated in Victorian style with potted palms, mirrors, and heavy furniture. The owners imported a candy maker from Switzerland. The candy he made was exquisite and is still made today in Fort Davis. (Courtesy of Junior Historian Files, Marfa Public Library.)

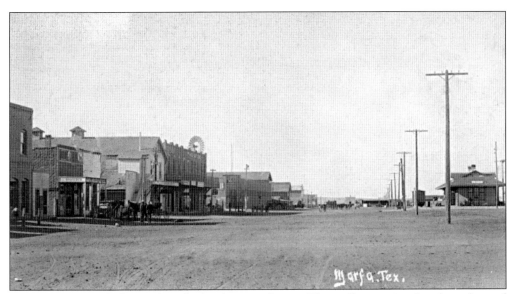

El Paso Street was the heart of Marfa's first business district. The roofline remains largely unchanged today, with many of the original buildings now renovated as artists' studios. (Courtesy of Junior Historian Files, Marfa Public Library.)

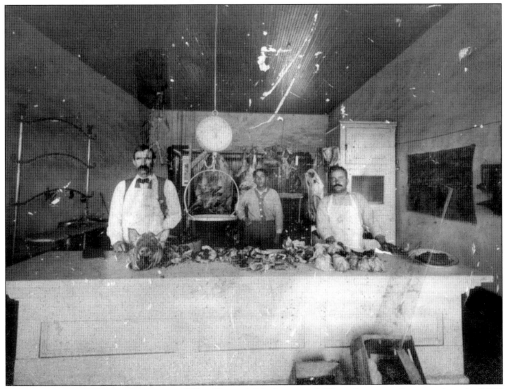

It is tempting to name this image "The Vegan's Nightmare." The photograph was taken in 1919 at the Miller Meat Market, located on El Paso Street. Notice the meat hanging on hooks at the back of the room and the pig's head on the counter. From left to right are John Miller, Salomon Miller, and Regino Jaime. (Courtesy of Junior Historian Files, Marfa Public Library.)

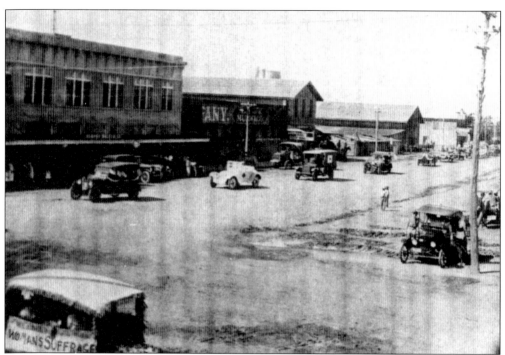

The women's suffrage movement was claiming the attention of progressive men and women everywhere at this time. Men did not dominate women out here. The pioneer women had their own very strong and influential place in this frontier town. (Courtesy of Junior Historian Files, Marfa Public Library.)

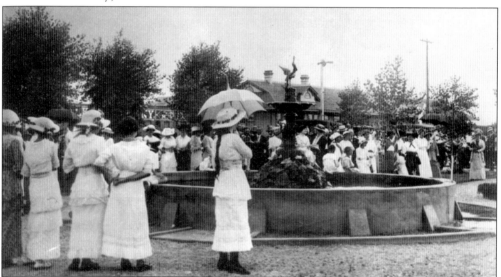

Located in the middle of town, Sunset Park was the center of activity on Sunday afternoons. The 6th Cavalry Band, augmented by musicians from the 4th Cavalry Band, gave concerts. The fountain was a gift to Marfa from the Marfa History Club in 1913. The *New Era* recorded, "The ever changing beauty of its tiny streamlets dancing in the sunlight. The pearly drops reflect the beauty and purity of those who placed it here." (Courtesy of Junior Historian Files, Marfa Public Library.)

Three

BORDER UPHEAVALS, WORLD WAR I, THE MILITARY, AND THE U.S. BORDER PATROL
1910–1924

The Mexican Revolution began in 1909–1910, when the Mexican citizenry revolted against the Mexican federal government. A small number of Mexican banditos took advantage of the resulting unrest and chaos along the border to make incursions into Texas and to raid area ranches. The raids were unjustly blamed on revolutionaries, including Francisco "Pancho" Villa.

The relationship of Marfa to the border area was not based on a barrier of any kind. The agricultural area around Presidio and the Rio Grande Valley provided work for Mexican nationals. Before this, many Mexicans came to Texas along the borderlands to work at the Shafter mines and on the newly established ranches.

Area ranches were often the victims of bandito raids during this time of upheaval and were in need of protection. As a result, the military arrived in Far West Texas and was well established prior to World War I. The U.S. Border Patrol was established in Marfa in 1924 to deal with illegal immigration in Far West Texas. However, the Border Patrol was also called into service to deal with the problems of smuggling brought about by Prohibition. Many of the problems that started at the time of the Mexican Revolution continue to this day.

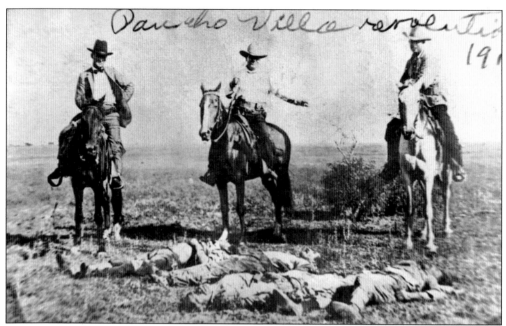

During the first week of January 1914, skirmishes developed between revolutionary forces led by Francisco "Pancho" Villa, "the Tiger of the North," and the *federales* in and near Presidio's neighboring Mexican city of Ojinaga. Villa's forces were ambushed by federal troops and were "slaughtered like cattle," one battle participant, Pedro Carbajal, recalled in an interview in 1965. Villa mounted a counterattack, and his artillery pounded the city and its trench fortifications. The federales, greatly outnumbered, lost heavily during the final two days of fighting. (Courtesy of Marfa Public Library.)

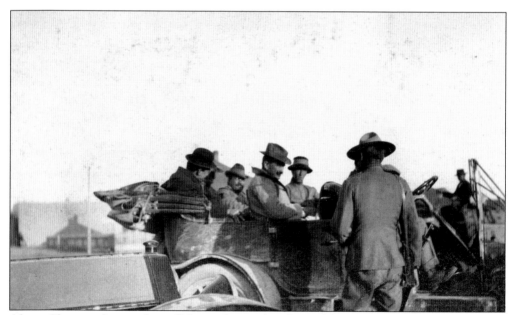

Alvaro Obregon, the president of Mexico during this phase of the revolution, is seen here in a car apparently observing some aspect of the conflict. (Courtesy of Bogel/Hubbard Collection.)

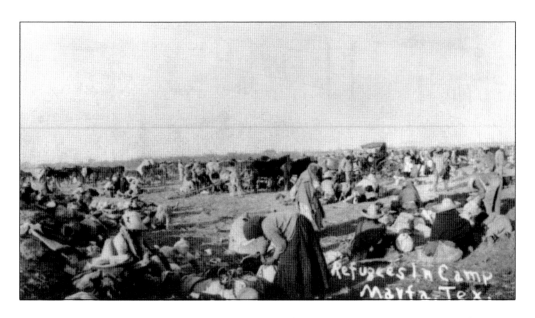

During January of 1914, more than 5,000 refugees fled Ojinaga in an attempt to escape the raging battle. Columns of refugees, including men, women, and children, made the long trek to Marfa. Many had to walk, while others rode horseback and in carts and wagons. A massive camp was set up for the refugees on the open plain just south of Marfa, now the site of old Fort D. A. Russell. After several weeks, the U.S. Army moved the refugees to Fort Bliss at El Paso, transporting them in freight cars. More than 100 carloads of refugees made the long train ride. (Above, courtesy of Junior Historian Files, Marfa Public Library; below, Duncan Collection, Marfa and Presidio County Museum.)

In spite of the hostile attitudes on both sides during the upheavals, the commanding officer of the Big Bend District counseled his troops against chasing Mexican banditos across the border unless American citizens were involved, and then only with the agreement of the Mexican commander. There were stringent rules for American troops about infringing on the sovereign rights of Mexico while also protecting American citizens. (Courtesy of Shannon Collection.)

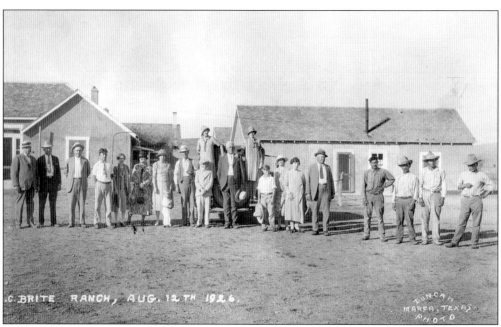

A well-publicized raid on the Brite Ranch headquarters on Christmas Day of 1917 was carried out by an unidentified group of Mexican banditos. The ranch foreman and his family were at home celebrating Christmas when banditos surrounded the house and barns and began shooting. The proprietor of the ranch store was killed. Word of the attack spread like wildfire from house to house in Marfa. Men left their Christmas dinners largely uneaten and went in hot pursuit of the banditos, who escaped across the Rio Grande without being apprehended. (Photograph by Frank Duncan; courtesy of Brite/White Collection.)

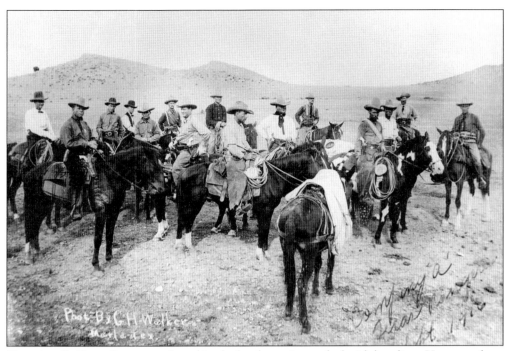

Occasionally Texas Rangers gathered in the border region to deal with banditos. However, these events did not always turn out well. The 1918 Nevill Ranch raid was initially blamed (probably erroneously) on Chico Cano, a Mexican bandito. After the raid, several local ranchers, soldiers stationed in Marfa, and a company of Texas Rangers led by Capt. Jim Fox went to the aid of the Nevill family. The Rangers, accompanied by a handful of ranchers, pursued the banditos across the Rio Grande into the tiny village of Pilares, where they rounded up a group of innocent local men and boys. The Rangers brought the captured Mexicans back to Texas and massacred them. Gov. Will Hobby subsequently dismissed Captain Fox and his entire company. It is not known if this c. 1918 photograph of unidentified Texas Rangers represents Fox's company. (Courtesy of Marfa and Presidio County Museum.)

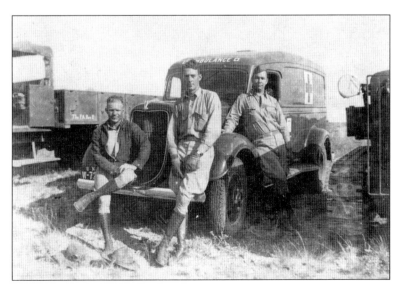

The story of World War I ambulance drivers has been described as a tale of "gallantry amid gore and manners amid madness." These Camp Marfa ambulance drivers represent the essence of life in the World War I Ambulance Corps—even in far off Marfa. (Courtesy of Marfa and Presidio County Museum.)

Camp Marfa and Royce Flying Field had some of the first planes used by the United States for military observation on the border. In 1919, two aviators took off from Marfa for a routine patrol of the border. After losing their bearings, they crashed inside Mexico and were captured by the notorious bandito Renteria and his men. Renteria sent word to Marfa demanding ransom. The entire ransom was pledged in less than 15 minutes by ranchers attending the annual Bloys Camp Meeting. After paying half the ransom money and successfully escorting one of the two aviators to the Texas side of the border, U.S. Army captain Matlock returned to negotiate the release of the second pilot. Without paying the second half of the ransom, Matlock grabbed the remaining pilot, and both fled on horseback, thereby saving money and lives. There is controversy as to the true story of the photograph below. Was it simply an army payroll gathering or the meeting to prepare the ransom money for the kidnapped pilots? (Both courtesy of Junior Historian Files, Marfa Public Library.)

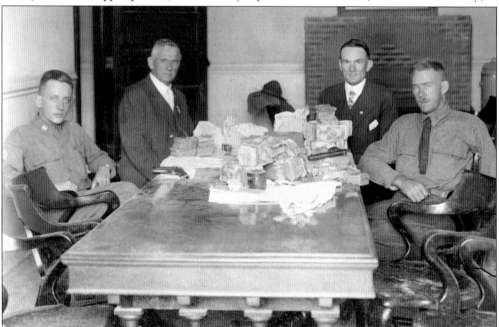

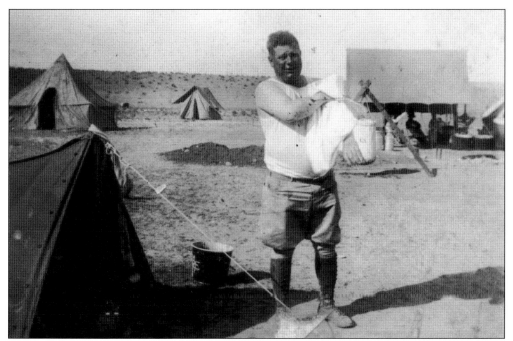

In spite of the hardships of living in this small tent and washing his ample body in a bucket, this soldier seems to be happily facing another day of combat training. (Courtesy of Marfa and Presidio County Museum.)

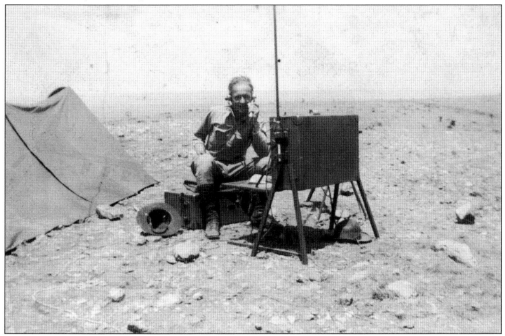

The radio operator of World War I was invaluable to the fighting men. Radios were portable either by mule or wagon and helped give advance warning to soldiers. These radios and radio operators also provided music and news for men in the trenches and hospitals. They were in Marfa with the military, stationed at Camp Marfa. (Courtesy of Marfa and Presidio County Museum.)

Although crude by any standards, World War I field hospitals were the home of innovative new trauma treatments, such as intravenous fluid replacement. Doctors and Red Cross nurses serving in field hospitals, such as this one located in Marfa, returned to private practice after the war armed with knowledge of new surgical techniques obtained during their term of duty. (Both courtesy of Duncan Collection, Marfa and Presidio County Museum.)

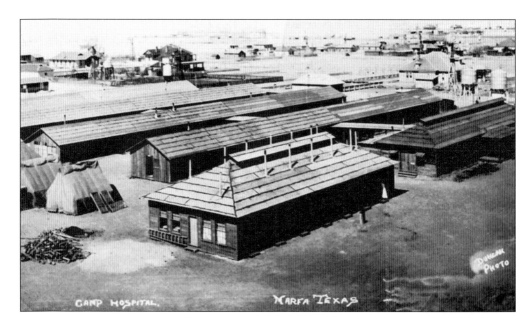

CAMP HOSPITAL. MARFA TEXAS

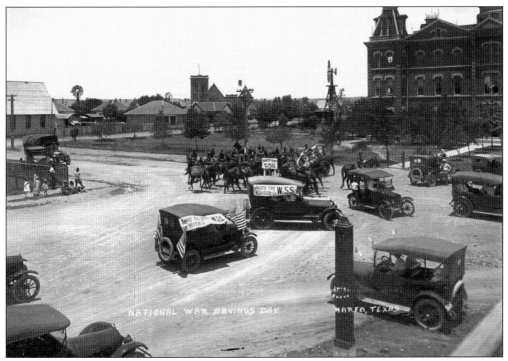

This Highland Avenue parade was in recognition of National War Savings Day. Note the harsh and poignant banners on the cars. They illustrate the hostility toward the kaiser that all felt at the time. (Courtesy of Duncan Collection, Marfa and Presidio County Museum.)

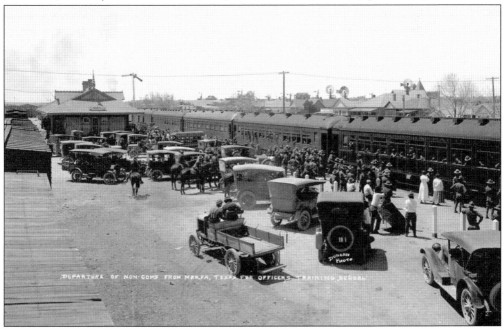

This was a familiar sight during the war years. Many who got on these trains came home permanently damaged or did not come back at all. Train depots must have seen a lot of sadness as well as happiness during the war. (Courtesy of Duncan Collection, Marfa and Presidio County Museum.)

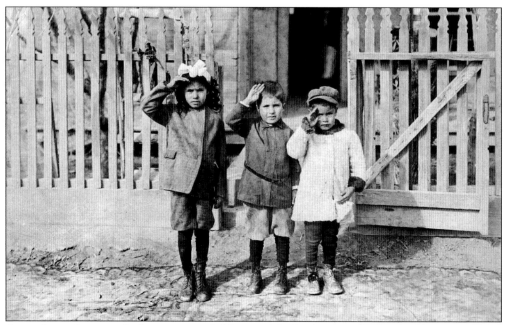

A touching photograph shows young children in Marfa. Apparently they had been taught to salute the troops stationed in the area. Patriotism was strong in the early part of the 20th century. One wonders if they understood what war meant. (Courtesy of Junior Historian Files, Marfa Public Library.)

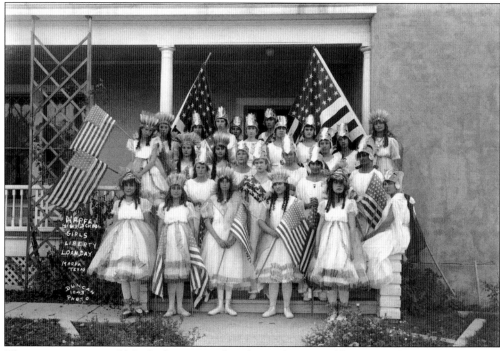

The young women of Marfa dress as Lady Liberty for a World War I rally. Someone had a difficult job sewing these elaborate costumes. (Courtesy of Duncan Collection, Marfa and Presidio County Museum.)

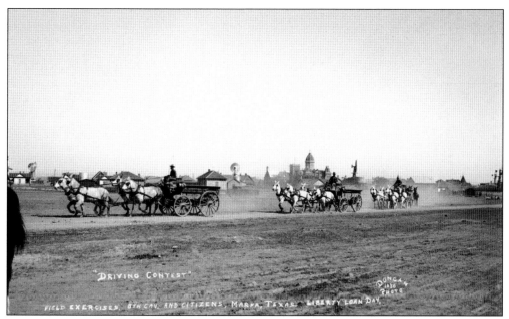

There was a great deal of interaction between the townspeople and the military during the time that the cavalry was stationed in Marfa. The military often presented field days for the local citizens. This Roman chariot race was one of the events with teams of mules and wagons. Note how the unusually large mules are perfectly matched, either white or dapple-gray. The San Esteban Ranch, which raised Percheron-donkey crosses, may have raised these beautiful dapple-gray mules. (Courtesy of Duncan Collection, Marfa and Presidio County Museum.)

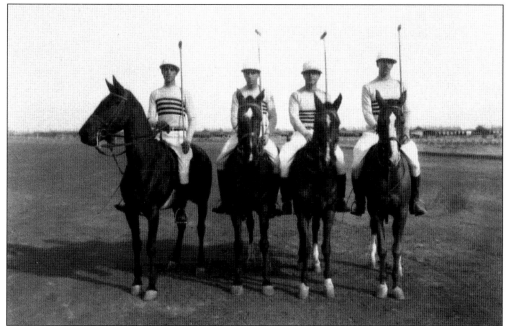

The Fort D. A. Russell polo team was highly accomplished and once, amidst enormous fanfare, visited Mexico City where they played the Mexican Army team. (Courtesy of Duncan Collection, Marfa and Presidio County Museum.)

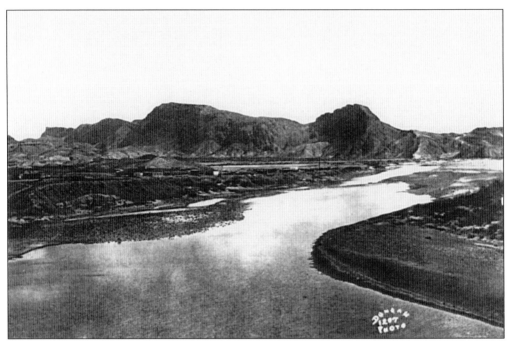

This photograph of the Rio Grande shows its size as it once was and illustrates how difficult it must have been for the U.S. Border Patrol to work the area. Portions of the river were wide and fast running with sections of rapids. Other places were narrow and slow, but either way it was a difficult river for lawmen to control. (Courtesy of Duncan Collection, Marfa and Presidio County Museum.)

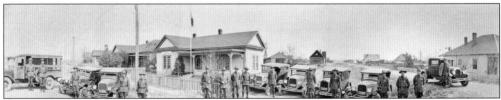

The Border Patrol headquarters was established in Marfa in 1924 on Austin Street in a building that still remains, although it is hard to identify due to numerous renovations. Note the classic paddy wagon and patrol cars in the photograph. (Courtesy of Duncan Collection, Marfa and Presidio County Museum.)

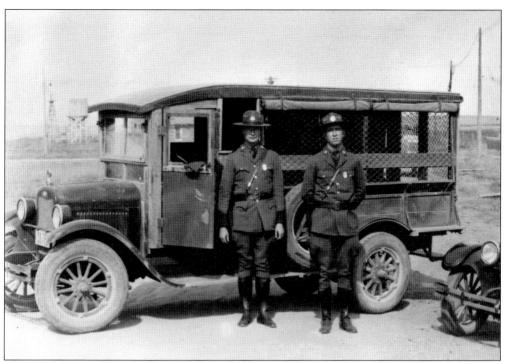

This paddy wagon looks much like the ones in the old movies. It is an amazing construction made especially to carry lawbreakers back to jail. (Courtesy of Junior Historian Files, Marfa Public Library.)

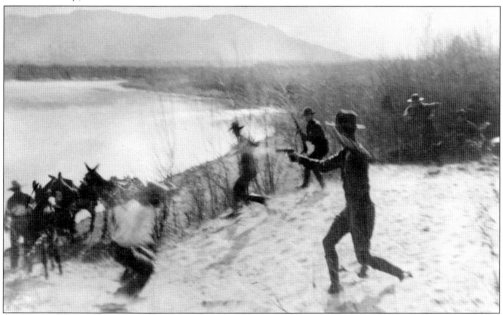

It was the usual practice of the Border Patrol to pursue illegal immigrants, who often ran for the river to avoid arrest. This remarkable picture shows a scene seldom photographed: a real pursuit of what appears to be a group of smugglers. (Courtesy of Junior Historian Files, Marfa Public Library.)

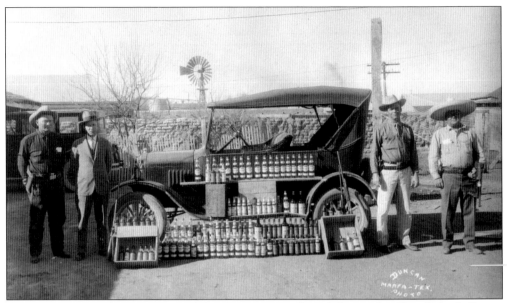

This picture was taken in 1919, and the four men are, from left to right, Sheriff O. C. Dowe, Hunter Metcalfe, Inspector Tom Walker, and Deputy Creed Taylor. Dowe found this car and its driver struggling to get up a steep hill. After Dowe helped push it to the top, he noticed something strange in the driver's demeanor and after investigation discovered an enormous load of contraband. One wonders how the bootlegger could get that much liquor in that car, much less endeavor to take it up a hill. (Courtesy of Junior Historian Files, Marfa Public Library.)

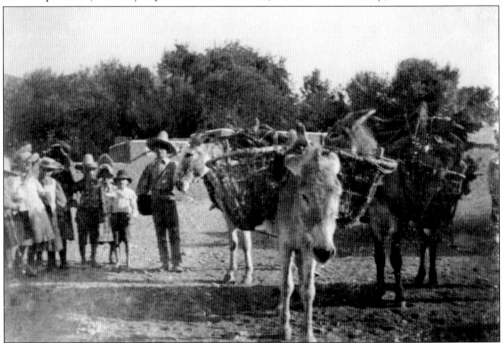

Bootleggers often brought their contraband to towns on burros and, after selling their liquor, abandoned the animals to freely roam the streets, where they were often adopted by the town's children. (Courtesy of Junior Historian Files, Marfa Public Library.)

Four

THE MATURING
OF A FRONTIER TOWN
1920s–1930s

By 1920, the military establishment at Camp Marfa had provided a relatively stable economy for the town. The end of the border upheavals and the end of World War I also contributed to better times, meaning community development, social as well as cultural. The shipment of cotton, cattle, and ore were the basis of the town's economy. In spite of reasonable prosperity in the cattle industry, signs of trouble were ahead.

Marfans were appalled by the Red Cross's report on the living conditions of Mexican Americans along the Rio Grande. The patron system, which greatly helped the conditions of ranch workers, did not apply to those not employed on ranches. The Mutualista Sociedad was started in 1922 to help needy Hispanics living in the border area. The League of United Latin American Citizens (LULAC) was organized around 1929 to create political unity for all Mexican Americans.

In Marfa, conformity to mid-American and middle-class values began to replace the earlier cow town values, even though many of the frontier customs continued to prevail. Ranching matured along with the town. With time, working conditions on the ranches and cattle-raising methods improved. Women began taking part in the ranching world and continued to do so throughout the hard times. Regrettably all of this advancement could not stave off the 1930s drought or the Great Depression.

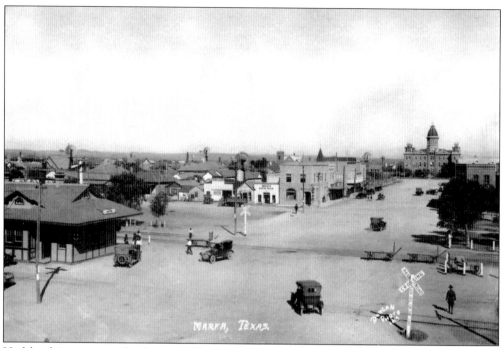

Highland Avenue was developing as the courthouse watched citizens of the town move around by automobile rather than horse-and-buggy. The street was still unpaved, and the depot in the bottom left corner of this photograph remained one of the centers of activity. (Courtesy of Duncan Collection, Marfa and Presidio County Museum.)

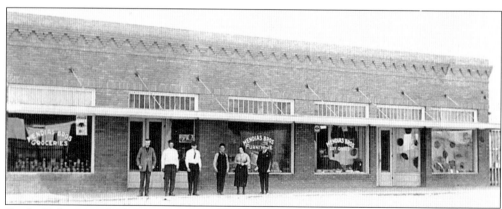

Cuida Chihua was the first name of this general store built by Luis Mendias and his sons in 1896. After Luis's death, it was renamed the Mendias Hermanos' Store. In this photograph taken on April 8, 1929, are, from left to right, Miguel Acosta, Anatacio Valenzuela, Alberto Mendias, Alberto Almenderez, Antonia Gonzales, and Urbano Mendias. The store is now the site of the Get-Go Grocery. The Mendias family also built the Teatro de Libertad immediately adjacent to the north, which today is a performance venue operated by Ballroom Marfa. (Courtesy of Junior Historian Files, Marfa Public Library.)

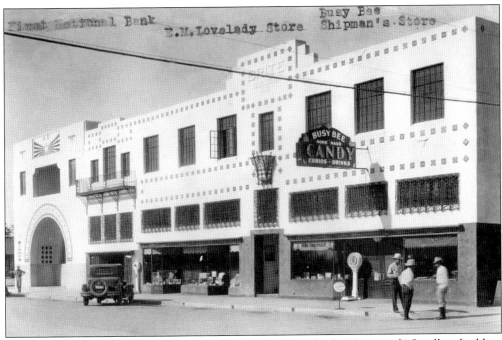

While the country was staggering from the stock market crash of 1929, a new $1.5-million building program was underway in Marfa. Directors of the Marfa National Bank razed the bank on the corner of Highland Avenue and Oak Street to construct a more modern building in its place. At the same time, L. C. Brite arranged to build a new complex next to the bank on Highland Avenue. It was occupied by Robinson's Jewelry Store and the Busy Bee Confectionery. By 1931, Marfa was beginning to feel the Depression, but these projects had proceeded without hesitation. (Courtesy of Junior Historian Files, Marfa Public Library.)

The Marfa Chamber of Commerce's plan to encourage a hotel project for the town began to take definite shape when C. N. Bassett and Associates, in conjunction with the Gateway Hotel Chain of El Paso, met with Marfa citizens in March of 1929. Work on the El Paisano Hotel began in November of 1929. The beautiful 60-room, Spanish-style structure designed by architect Henry Trost was completed in 1930. A grand ball was staged, and notables arrived to celebrate. (Courtesy of Marfa and Presidio County Museum.)

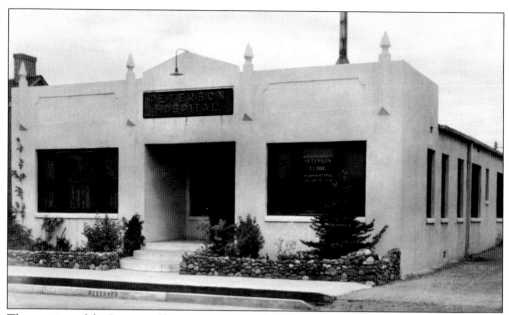

The opening of the Peterson Clinic in 1930 was of immediate benefit to Marfa and the area. The building was designed by L. G. Knipe and was paid for by L. C. Brite. The clinic is located east of the present-day Masonic Building. Its wards were open to all physicians of Marfa. The maternity ward was specially equipped. (Courtesy of Junior Historian Files, Marfa Public Library.)

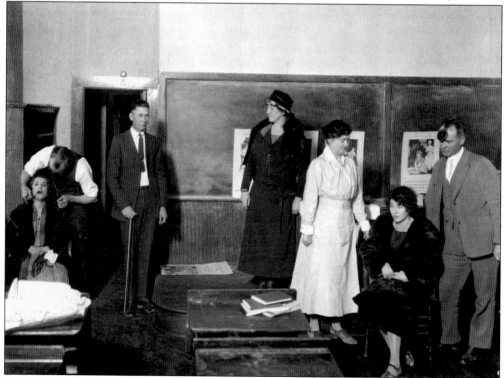

Doctors and dentists routinely used a schoolroom as a temporary clinic prior to the building of the Peterson Clinic. (Courtesy of Marfa and Presidio County Museum.)

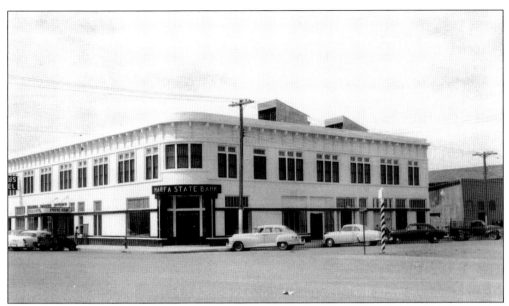

A number of new businesses opened in 1938, including the Crews Hotel, which was located in the former Murphy and Walker building. Billy Crews was manager of the hotel and coffee shop. The hotel also contained a new central bus station for both the Baygent and Union Bus Lines. The Marfa State Bank occupied a space as well. (Courtesy of Junior Historian Files, Marfa Public Library.)

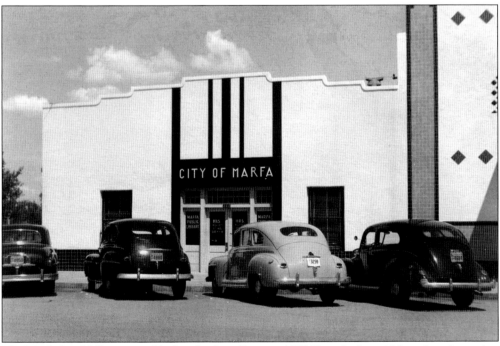

The Marfa City Hall is pictured before the fire of January 1995. Note the beautiful art deco decoration on the building. (Courtesy of Marfa and Presidio County Museum and *Big Bend Sentinel*.)

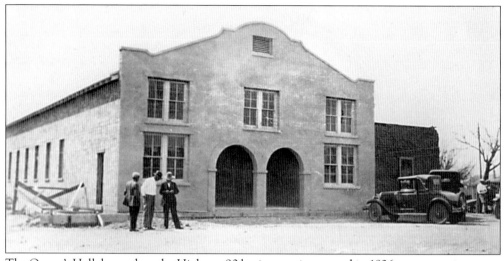

The Queen's Hall, located on the Highway 90 business strip, opened in 1926 as a recreation space and dance hall for the Hispanic community when Marfa was still a segregated town. It was home base for a group of men who were subtly fighting the problems of segregation. It is now the home of Ballroom Marfa. (Courtesy of Junior Historian Files, Marfa Public Library.)

Marfa was progressing at an amazing pace. The installation of a new sewer system was a modern advancement for the frontier town. (Courtesy of Junior Historian Files, Marfa Public Library.)

As the town matured, many civic and social clubs and organizations were formed for the betterment of the town. Here the Girl Scouts of Marfa gather for a meeting. (Courtesy of Junior Historian Files, Marfa Public Library.)

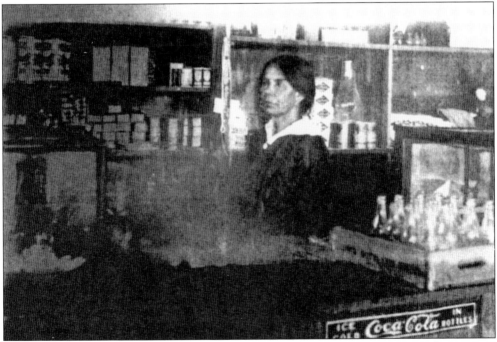

This general mercantile store was owned and operated by Josefa Carrasco. A teacher prior to marrying Rafael Carrasco, she established and operated the grocery store when the family moved from Terlingua so that the Carrasco children, who were old enough to attend school, could do so in Marfa. (Courtesy of Junior Historian Files, Marfa Public Library.)

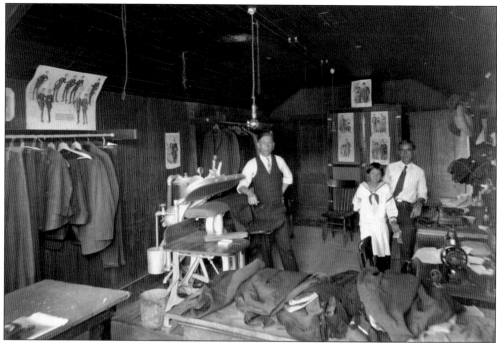

The people in this tailor shop are unidentified. The style of the suits appears to be from the 1920s, as does the child's sailor outfit. How wonderful it would be to once again have access to services such as these. (Courtesy of Junior Historian Files, Marfa Public Library.)

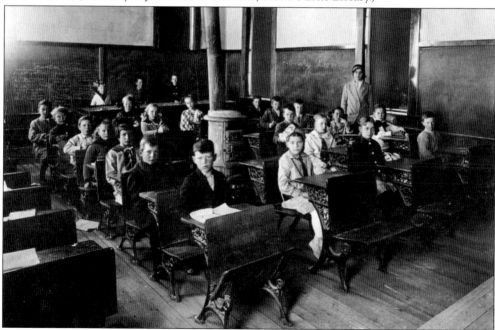

The educational situation in Marfa was improving, as the new public school had been built. This photograph shows children of the town having class in the new building. For a frontier town, the new public school was an unusually substantial two-story brick building. (Courtesy of Marfa and Presidio County Museum.)

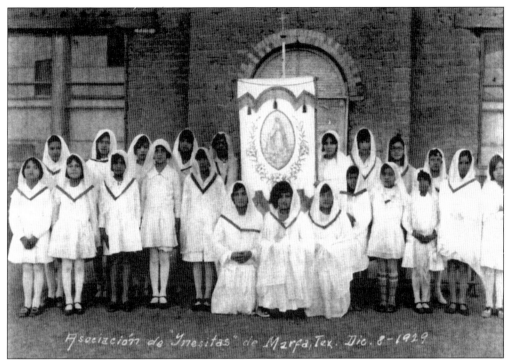

Members of the Society of the Treistas of Marfa are pictured around 1929. The Treistas was a group of young girls and women who prayed to the Virgin of Guadalupe. (Courtesy of Junior Historian Files, Marfa Public Library.)

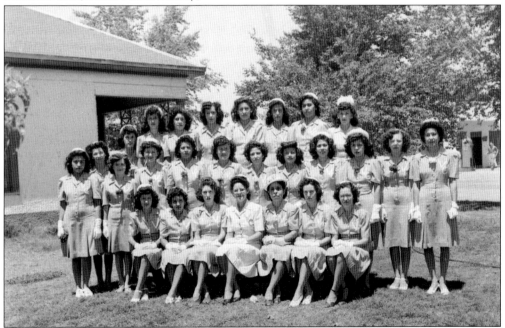

In 1939, Mrs. Lupe Teofilo Hernandez founded a service club for the Hispanic women of Marfa. The Violettas gave money to the poor and to the Catholic Church and were of great service to the community. (Courtesy of Junior Historian Files, Marfa Public Library.)

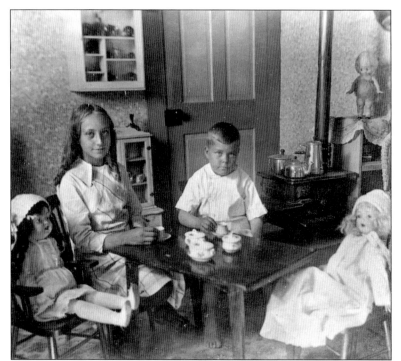

The younger set of Marfa was also encouraged to mind their manners as gentrification was coming to the frontier. Here the Chaffin children, Helen and Willie, have a tea party with their dolls. (Courtesy of Marfa and Presidio County Museum.)

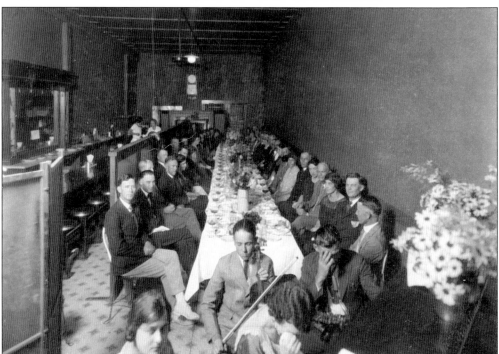

As the town grew, so did the cultural life of its citizens. The women of the town made sure their children were exposed to literature, music, and theater. Here a banquet is apparently graced with the music of a string quartet and piano. Note the less-than-enthusiastic listener in the lower right corner. (Courtesy of Duncan Collection, Marfa and Presidio County Museum.)

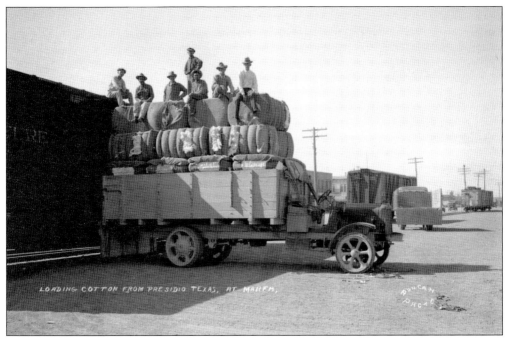

A load of Presidio cotton awaits shipment in 1930. The wagons are parked in front of the Murphy and Walker building located across the street from the train depot. (Courtesy of Junior Historian Files, Marfa Public Library.)

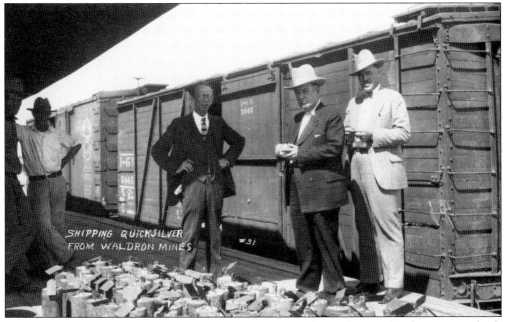

The Waldron Mines and the Mariposa Mining Company, located west of Terlingua, were both owned and operated by the Normand brothers of Marfa. Ore was transported by wagon train from the mines to the shipping point in Marfa, and supplies were sent to the mines on the return trip. The mining operations began in 1896 and fed the economy of Marfa for many years. (Courtesy of Junior Historian Files, Marfa Public Library.)

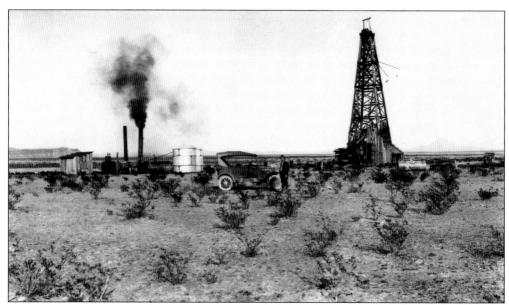

An amazing photograph of early oil exploration in Far West Texas provides a good example of the layout for a drilling site. On the left, the boilers that drove the old steam rigs are smoking away. This was before the days of the rotary bit invented by the Hughes Tool Company. The old-style drills would just pound their way through the rock. Insignificant amounts of oil have been found in the region. As one member of a pioneering ranch family put it, "We drilled on the land one time, hit granite, and that was that!" (Courtesy of Marfa and Presidio County Museum.)

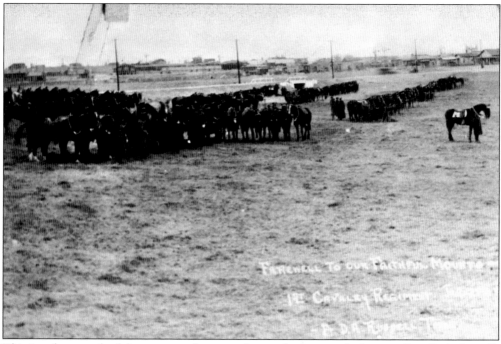

This is a photograph of the ceremony honoring Louie, the last cavalry horse at Fort D. A. Russell. A plaque commemorating Louie remains at the site. (Courtesy of Junior Historian Files, Marfa Public Library.)

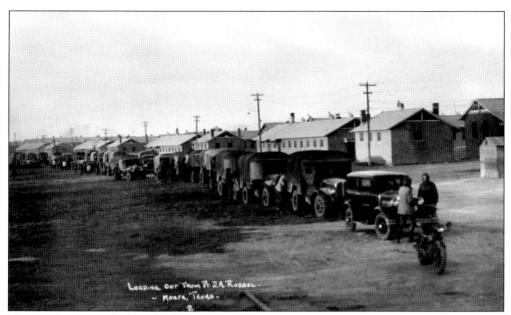

The cavalry troops stationed at Fort D. A. Russell were moved to Fort Knox, Kentucky, in 1933. Here is the caravan of machine and men moving out of the fort. (Courtesy of Junior Historian Files, Marfa Public Library.)

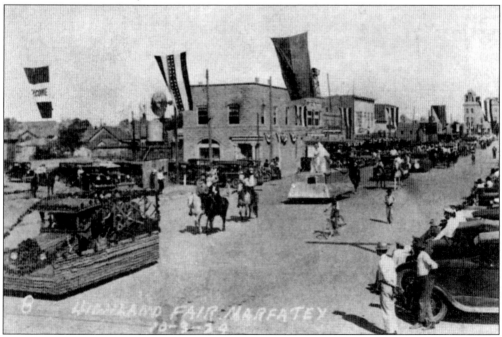

Active from 1928 to 1941, the Highland Fair was sponsored by the Highland Hereford Breeders Association to better the community and attract buyers to the region to see and buy their Highland Herefords. The fair consisted of a parade, rodeo, dances, football games, horse racing, and a carnival. The queen's coronation was also included in the festivities, as was a feeder sale, barbeque, and crafts competition. The fair was the highlight of the social season in Marfa. (Courtesy of Marfa and Presidio County Museum.)

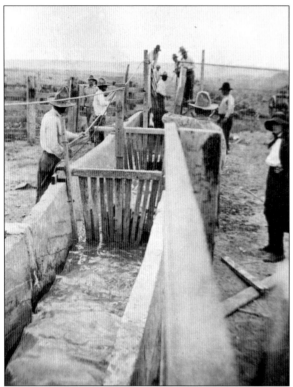

The dipping vat was a tool used to prevent diseases caused by ticks and other pests. The cattle were driven down a sloped ramp into the vat. The dip was extremely poisonous, as it contained arsenic. (Courtesy of Marfa and Presidio County Museum.)

Times were getting tough during the Depression. One of the local ranchers was heard to say that his clothes were so worn out he would have to wear his evening clothes to work if things didn't get better soon. This sparked the idea of the Depression Roundup, with all the men working in their tuxedos. During this roundup, word arrived that the cattle market had gone up considerably. (Courtesy of Junior Historian Files, Marfa Public Library.)

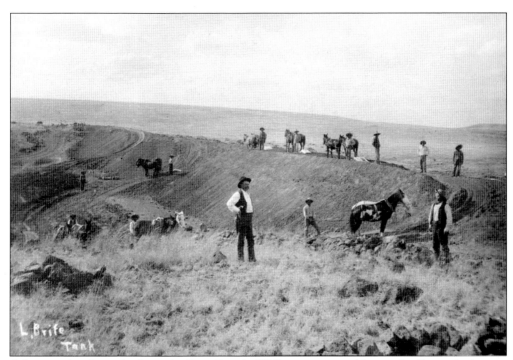

A large tank is being built on the Brite Ranch. Well water pumped by windmills supplied a vast pipe system that served distant pastures on the ranch. At one time, the ranch had over 100 miles of water lines. (Courtesy of Brite Collection, Marfa and Presidio County Museum.)

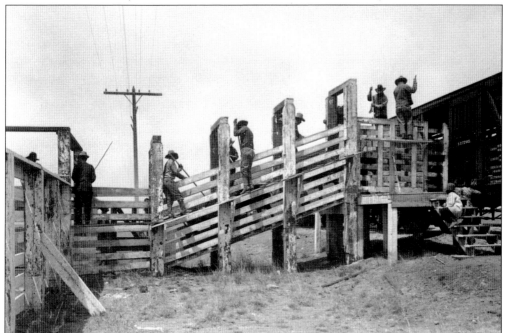

The "bull board" was a heavy ramp that connected the railroad car to the chute. The art of handling this heavy piece of equipment was a source of pride to the cowhands, who became experts at this job. (Courtesy of Junior Historian Files, Marfa Public Library.)

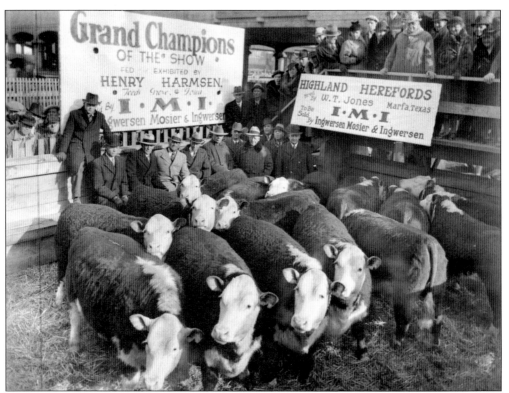

Due to the efforts of the Highland Hereford Breeders Association, cattle raised in the Marfa area were very popular in the Midwest as feeder cattle and were a profitable source of income for ranchers in Far West Texas. W. T. Jones of Marfa captured the Grand Champions of the Show with his Highland Herefords in 1930. These cattle were bred to be sold to feed lots in the Midwest, where they were fattened even more and then sent on to slaughterhouses. (Courtesy of Junior Historian Files, Marfa Public Library.)

The town had grown steadily, but in this period photograph, one can still see many windmills providing water for the town. The Brite home is to the right in this picture. (Courtesy of Duncan Collection, Marfa and Presidio County Museum.)

Five

WORLD WAR II
AND THE WAR EFFORTS
1941–1945

On December 7, 1941, Marfans were glued to their radios for more news of the attack on Pearl Harbor. Fort D. A. Russell was put into security lockdown. Many of the men from the area were drafted or volunteered for a branch of the service. Troops were coming in and out constantly, even before the Pearl Harbor attack.

The entire necessary infrastructure for a military base rose out of the desert almost overnight to accommodate the U.S. Army Air Force Advanced Flying School. Training operations began on December 11, 1942, at the Marfa Army Air Field east of town.

Preparations to build a United Service Organization (USO) got under way. A new attitude toward enlisted men had arrived, and the civilian and military population began working together to protect the town and to make life easier for the service personnel. A club was also started for the then segregated black soldiers stationed in Marfa.

A historian of the 81st Battalion described Marfa as "a little cow town with a big sense of hospitality and a bit of Old Mexico—a vast waste with plenty of space, without a blade of grass or a tree." Soon the charms of the plains, the rugged beauty, the mellow sunlight, and glorious nights won all over.

The social life of Marfa, with few exceptions, included servicemen. The entire region was feeling the effects of war, either through war work or the lack of young men in the area. The 81st Battalion distinguished themselves in Europe from D-Day onward.

The wartime economy of Marfa accelerated, as it did everywhere. Servicemen were on the streets and planes were in the sky.

As the war ground to a close, the glory days of military activity were over, and Marfa would never be the same again, or at least it would be in recession for a long time. The decline of the economy was soon on its way.

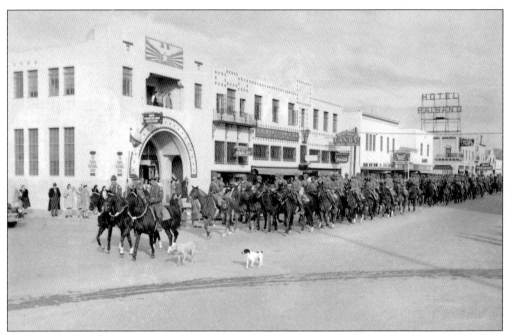

The Presidio County Courthouse stood sentinel for Marfa as America's active engagement in World War II loomed on the horizon. In this c. 1941 photograph, soldiers stationed at Fort D. A. Russell participate in a parade down Highland Avenue. (Courtesy of Marfa and Presidio County Museum.)

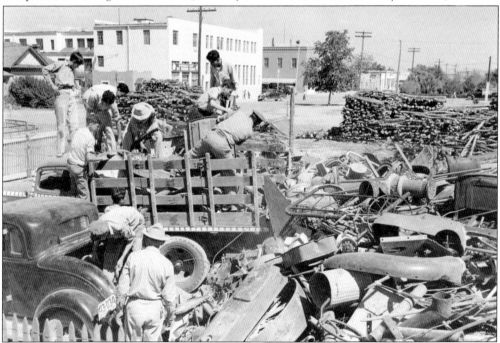

A scrap metal campaign conducted by the Rotary Club was launched in October of 1942. One hundred pounds per capita was sought. Judging by the enormous piles of accumulated scrap metal depicted in this photograph, it appears the Rotary Club met its quota with some to spare. (Courtesy of Marfa and Presidio County Museum.)

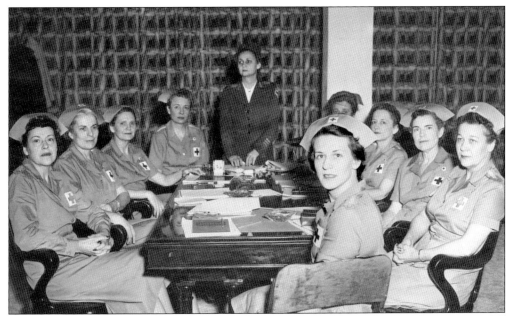

As always, Marfa women stood ready to meet the needs of others. Their war efforts were in full swing by early January 1942, when the Jeff Davis and Presidio County Red Cross quota, set at $2,200, was oversubscribed and organization membership exceeded 1,000. (Courtesy of Marfa and Presidio County Museum.)

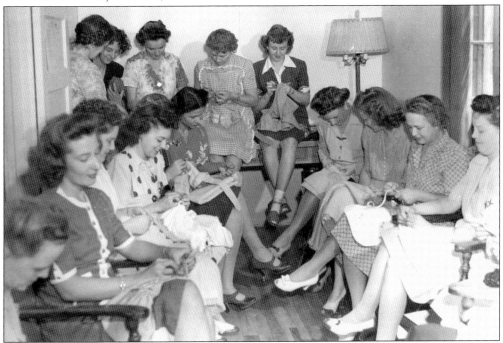

Clothes of all kinds, especially warm ones, were desperately needed in this country and overseas during World War II. The wives of officers were called upon to sew and knit. These ladies enjoyed friendship and camaraderie at the Officers' Wives' Club while they contributed their skills to the war effort. (Courtesy of Marfa and Presidio County Museum.)

As often seen in the movies, not everyone spent the entire war fighting at the front. Shoe trading got a laugh here from everyone but the lady standing in the doorway. Is that a look of disapproval, a smirk, or a desire to join in? Did his feet hurt from being crammed in this woman's shoe, or did the lady have big feet? (Courtesy of Marfa and Presidio County Museum.)

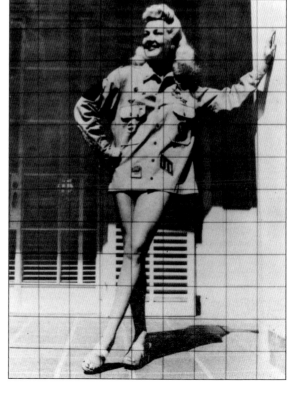

Betty Grable, with legs insured for $1 million, was the pinup queen of World War II. Her picture graced the footlockers, airplanes, and barracks walls of every military installation in this country and abroad. Here is a photograph of Betty in her military uniform overlaid with a grid to facilitate its transfer to airplane fuselages. (Courtesy of Marfa and Presidio County Museum.)

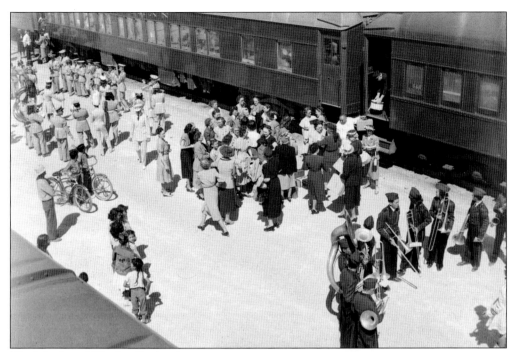

The Marfa and Blackwell school bands are on hand to help welcome an incoming train loaded with military fathers, sons, husbands, and boyfriends arriving home on furlough. No doubt similar scenes were played out at thousands of train stations across America during the war years. (Courtesy of Marfa and Presidio County Museum.)

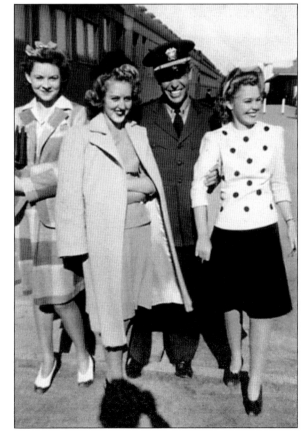

Is it any wonder that this airman has a big smile on his face as he is met by three very fashionably dressed lovelies? One can almost hear the beat of boogie-woogie music playing in the background. (Courtesy of MacDonald Collection.)

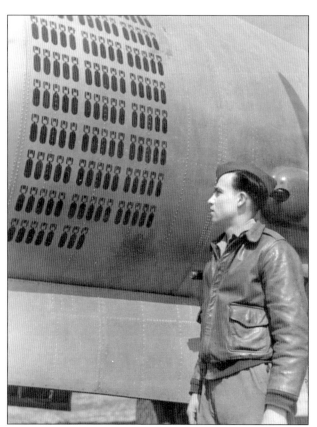

Bombs away! This airman had survived a lot of missions. As was customary throughout the war, he painted bombs on the fuselage of his plane to record the number of missions successfully flown over enemy locations. (Courtesy of Marfa and Presidio County Museum.)

The Marfa area had its share of casualties. At a Marfa Army Air Field review in August of 1944, the Winters family of Alpine receives a salute in recognition of the loss of their son in action. (Courtesy of Marfa and Presidio County Museum.)

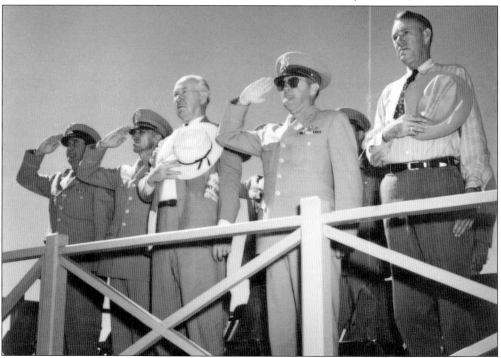

Six

THE POSTWAR YEARS AND THE DECLINE
1946–1976

The postwar years became a sad story for a once vibrant town that really flourished in its earlier years. When the military left in 1946, the closing of Fort D. A. Russell and the Marfa Army Air Field stunned the town.

Back to back with this enormous change came the devastating 1950s drought. Although it was not noted in the newspaper at the time, there were many sales and foreclosures on ranches. This in turn caused a business decline in town.

By the 1960s, the social and cultural life of Marfa was abysmal. However, there was one bright spot on the horizon in the late 1960s. At this time, Marfa had begun hosting annual soaring meets. They had become popular with enthusiasts of the sport, and Marfa was a gracious and willing host to the activities.

In the 1960s and into the 1970s, government programs were in wider use. In the 1970s, the general tenor of life in Marfa was in much the same deteriorated state that it had been in the prior decade.

Drugs and problems with undocumented migrants from Mexico ran rampant. The U.S. Border Patrol was very active in these situations but was unpopular with ranchers, who needed the cheap labor, and with the people from Mexico, who needed the jobs.

It appeared that Marfa had seen better days.

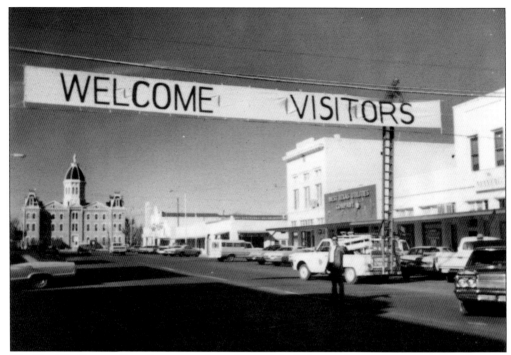

The Presidio County Courthouse stood watch over Marfa during the postwar years, when drought and loss of the military had a profound effect on the economy. However, "Welcome Visitors" was still the attitude around town, and good cheer abounded. (Courtesy of Marfa and Presidio County Museum and *Big Bend Sentinel*.)

The ladies of Marfa entertained and paid homage to their frontier days. This photograph shows the Marfa Study Club holding a pioneer tea in 1976. (Courtesy of Brite/White Collection.)

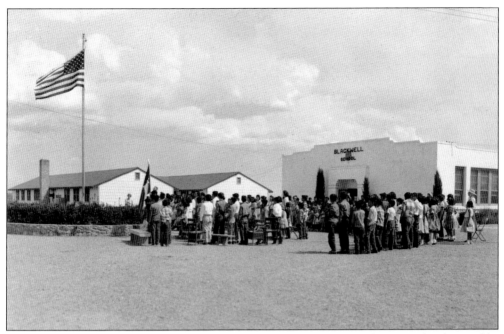

Hispanic students of the segregated Blackwell School raise the Texas flag at a school assembly. (Courtesy of Marfa and Presidio County Museum.)

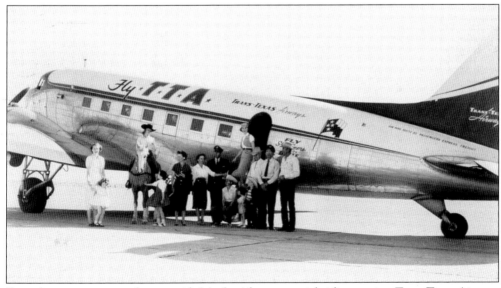

Several attempts were made to provide Marfa with commercial airline service. Trans-Texas Airways served Marfa in the 1950s, but eventually only private and charter flights carried air travelers in and out of Marfa. (Courtesy of Marfa and Presidio County Museum.)

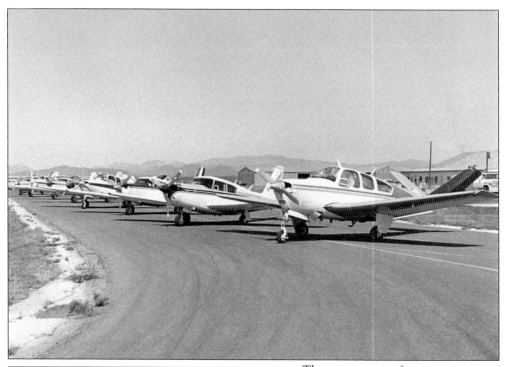

There was an air of postwar extravagance in Marfa during the 1950s, when many ranchers owned their own planes. (Courtesy of Marfa and Presidio County Museum.)

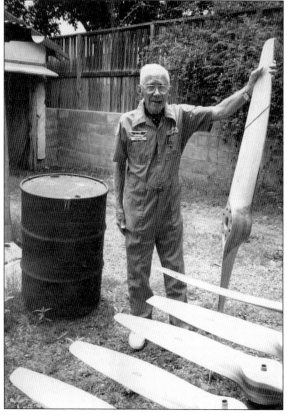

Ray Hegy was known about town as the "Little Propeller Man." After mapping the Amazon as a young man, he settled in Marfa and became a craftsman of some note by building beautiful wooden propellers for private airplanes. He also built the smallest plane on record at the time, called the *Chuparrosa*, which means "hummingbird" in Spanish. (Courtesy of Junior Historian Files, Marfa Public Library, and Mrs. Georgie Lee Kahl.)

This remarkable photograph captures sisters Nellie Howard (left) and Marian Walker (right), descendants of the Kilpatrick family, negotiating what appears to be an international matter mid-Rio Grande, in neutral territory. The sisters' father was killed in the line of duty while working as a customs officer along the river. After his death, the sisters traveled on horseback, covering the entire area mentioned in their father's diary. They owned and operated the general store in Candelaria into the early 1990s. (Courtesy of Marfa and Presidio County Museum.)

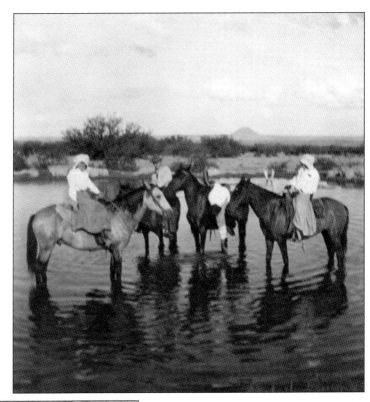

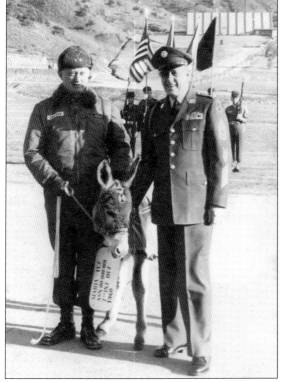

PFC Marfa-Tex arrived in Korea for duty in 1960. He was sent, with the help of then Sen. Lyndon Johnson, as a mascot for the 7th Infantry Division stationed in Korea at that time. Upon arrival, the donkey stood at attention as General Sanford hung a dog tag around his neck. He was promptly given honorary membership in the honor guard. (Courtesy of Marfa and Presidio County Museum and *Big Bend Sentinel*.)

Marfa mourned the loss of a good citizen and lawman in 1950, when Blackie Morrow was shot and killed while attempting a single-handed arrest near Big Bend. An armed posse of horsemen went in pursuit of the killer, who fled into the mountains north of the Rio Grande on foot, but they lost the trail near the Mexican border. (Courtesy of Marfa and Presidio County Museum and *Big Bend Sentinel*.)

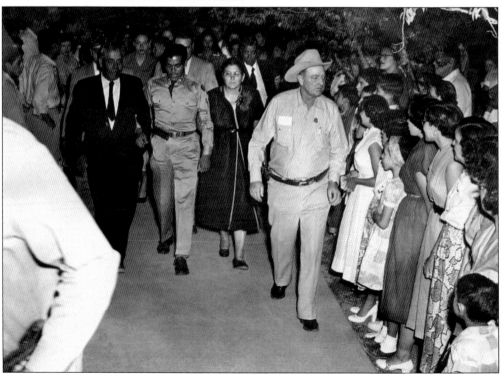

Laureano Jimenez is welcomed back home after his release from a prisoner of war camp where he was held during the Korean War. (Courtesy of Junior Historian Files, Marfa Public Library.)

The Holiday Capri was owned and operated by Eddie Pierce and his wife, Wanda. The couple also owned the Motel Thunderbird and the adjacent Thunderbird Restaurant. (Courtesy of Marfa and Presidio County Museum and *Big Bend Sentinel*.)

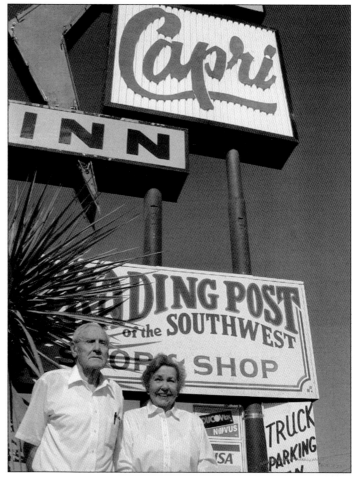

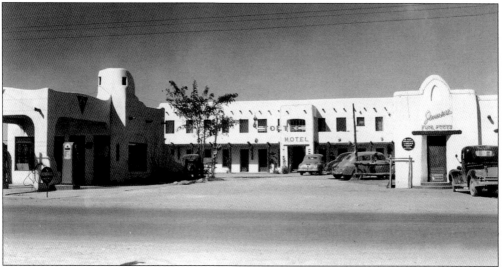

The Toltec, a motel and café that operated during the postwar years, was a large and attractive structure located on Marfa's Highway 90. (Courtesy of Marfa and Presidio County Museum.)

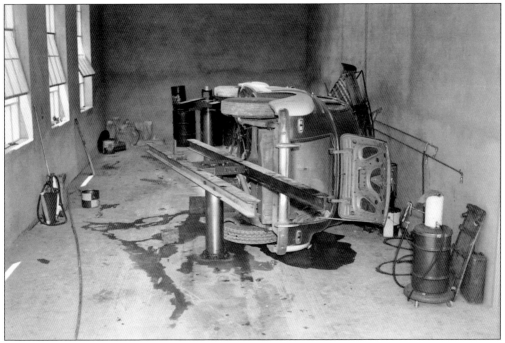

Presently this is the base of the glass-topped table at the Blue Javelina Restaurant, but in earlier times it did much harder work lifting and positioning cars so the mechanic could do his job. (Courtesy of Marfa and Presidio County Museum.)

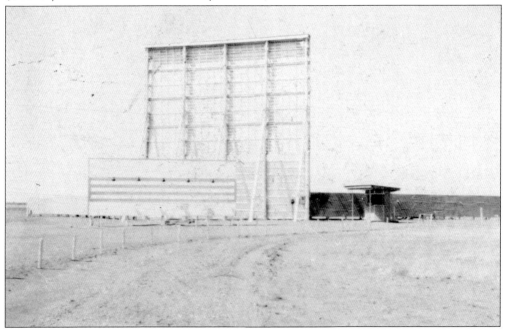

Drive-in theaters provided a popular and affordable form of family entertainment everywhere across America during the postwar years, and Marfa's drive-in was no exception. The high desert climate lent itself to sitting under the stars to watch the latest movie release. (Courtesy of Marfa and Presidio County Museum.)

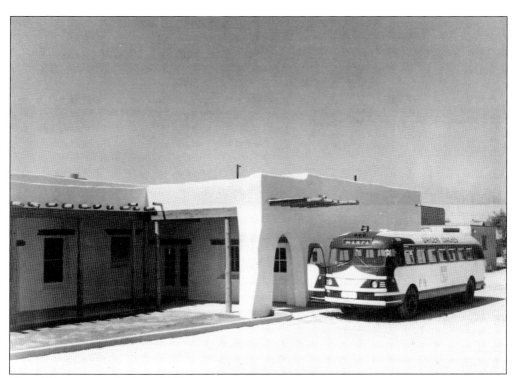

The old bus station, built in 1945, served the Baygent Bus Lines carrying passengers from Marfa to towns all over West Texas. The station has subsequently been renovated as a private home. (Courtesy of Marfa and Presidio County Museum.)

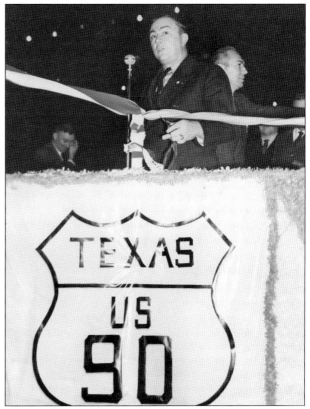

Highway 90 was constructed in the postwar years, making Marfa more accessible to the outside world. This photograph shows the ribbon-cutting ceremony that celebrated the opening of the highway, now designated a part of La Entrada al Pacifico. (Courtesy of Marfa and Presidio County Museum and *Big Bend Sentinel*.)

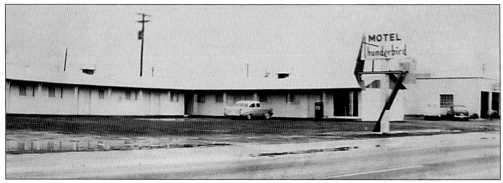

The Thunderbird Motel was one of the few accommodations available in Marfa after World War II. The Thunderbird has been renovated and is now one of the hip hotels of Texas. (Courtesy of Marfa and Presidio County Museum.)

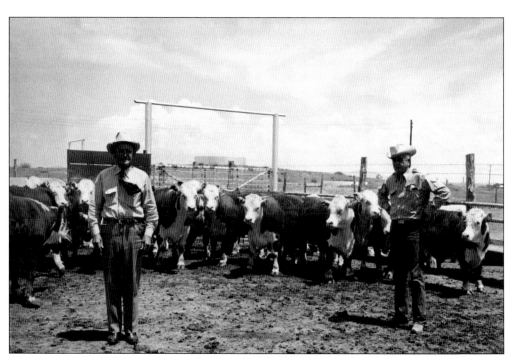

Although the cattle business was in decline after World War II, the cattlemen continued to raise and sell prime beef cattle. The man on the left may be a cattle buyer. The rancher on the right is giving him that kind of look. (Courtesy of Marfa and Presidio County Museum.)

Earnest D. "Hank" Hamilton, Presidio County sheriff, was killed in the line of duty on a ranch west of Marfa in 1973. He was well respected by the town, which considered him not only a fine law officer but a friend as well. Here Hank is pictured with his wife, Mary. (Courtesy of Marfa and Presidio County Museum and *Big Bend Sentinel*.)

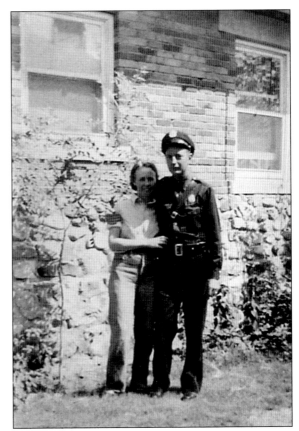

The introduction of sheep and goats to the ranchland around Marfa contributed to the wholesale slaying of mountain lions in the postwar era. (Courtesy of Marfa and Presidio County Museum.)

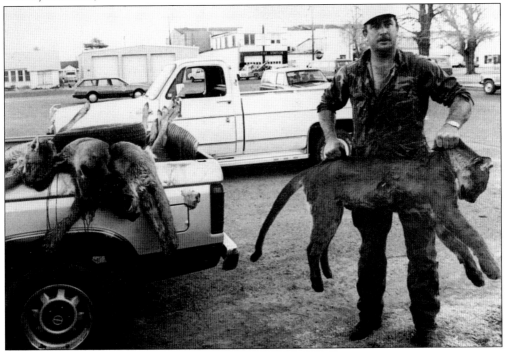

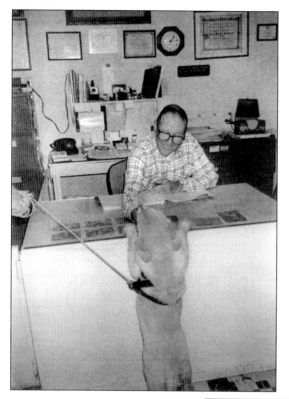

Charles Edwards was the town veterinarian, a friend to animals and their owners as well. He had an amazing way with animals, as this photograph shows. His patient seems eager to see the doctor, who was always kind and gentle to all brought in for his attention. Dr. Edwards's autobiography, *Up To My Armpits*, was published in the 1990s and is both colorful and informative. (Courtesy of Marfa and Presidio County Museum.)

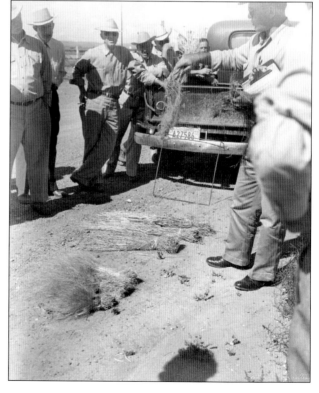

The drought of the 1950s and the introduction of sheep and goats to the rangeland wreaked havoc with the natural grasses of the desert. Often, after one season of grazing these animals, there would not be a crop of grass the next year. U.S. Soil Conservation employees would come in to instruct and advise the ranchers on restoring the natural grasses of the high desert. (Courtesy of Marfa and Presidio County Museum.)

Seven

SPECIAL EVENTS

Why did people come to Marfa? What brought and continues to bring special events here? "Climate, space in a world of ever diminishing space," and "accommodating people who welcome diversion" are a few of the answers one gets to those questions. These attributes continued to attract visitors to Marfa in spite of the depressed state of the town in the postwar years and into the late 1990s.

Historically Marfa attracted outstanding forms of entertainment such as traveling companies of opera and theatre. There was always an appreciative audience in Marfa that did not exist in other parts of the region. Today the attraction continues for entrepreneurs as people of many interests are drawn to the climate, the space, the terrain, and the accommodating attitudes of the citizens.

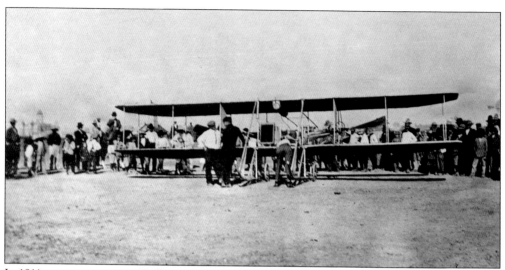

In 1911, newspaper tycoon William Randolph Hearst offered a $50,000 prize to the first man to fly from coast to coast in 30 days. Calbraith Perry "Cal" Rodgers attempted to meet the challenge by flying the *Vin Fizz*, an open-wing biplane, from Brooklyn, New York, to Long Beach, California. His flight took 84 days, so he didn't win the Hearst prize. However, he was awarded $20,000 from Armour, the company that sponsored his flight. While achieving his goal of being the first to make a transcontinental flight, Rodgers landed in Marfa along the way. He attracted much attention from the townspeople, many of whom had never seen an airplane. (Courtesy of Junior Historian Files, Marfa Public Library.)

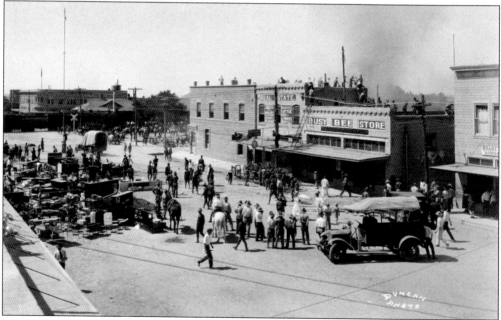

Marfa suffered a disastrous fire in 1920. The blaze started in an auto shop and spread to several adjacent buildings. The bucket brigade was unable to extinguish the fire, and there was great loss of property. The cavalry came to help, but the horses had to be kept down the street because the smoke was so thick. Note the goods from the nearby stores piled in the middle of Highland Avenue to keep them from burning. (Courtesy of Marfa and Presidio County Museum.)

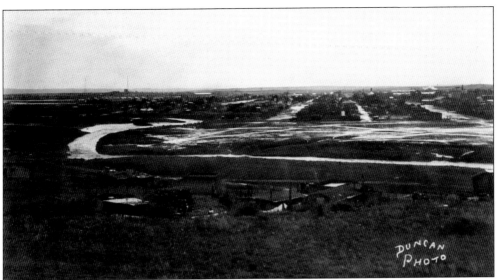

Marfa had many small floods until a series of control dams were built along Alamito Creek. A major flood in 1920 affected Marfa's entire main business district. (Courtesy of Duncan Collection, Marfa and Presidio County Museum.)

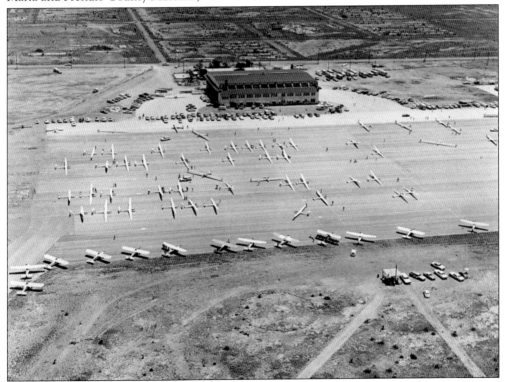

The 1967 and 1968 National Soaring Championships and the 1970 International Soaring Competition were held at the former Marfa Army Air Field east of town. Soaring in Marfa has always been a pleasure, whether for badges, records, distance, or fun. The Marfa area has the best dew-point lines and a dry line that provides unique uplift conditions, making it the perfect place for soaring. (Courtesy of Mrs. Georgie Lee Kahl.)

Astronaut Alan Shepard visited Marfa prior to the first moon landing. Shepard, here with Marfa local Nancy Stover, explored the distinctive terrain around Lajitas, which strongly resembles the moon's surface. Later the group accompanying Shepard used the McDonald Observatory's world-acclaimed telescopes to observe the moon with the most advanced equipment available at the time. This was a very exciting event for the entire town, including the lady in curlers. Chuck Yeager, the first man to break the sound barrier, also came to Marfa on a speaking tour at a later date. (Courtesy of Marfa and Presidio County Museum.)

George Cook, the cook at the Crew's Hotel for a number of years, is seen barbequing some wonderful chicken. Was he cooking for the restaurant or did he do catering on the side? Note his crisp white chef's toque. It couldn't have been easy to keep his outfit so white and clean with the dust blowing and smoke surrounding him. From the amount of chicken on his grill, he could have been cooking a feast for the military. (Courtesy of Marfa and Presidio County Museum.)

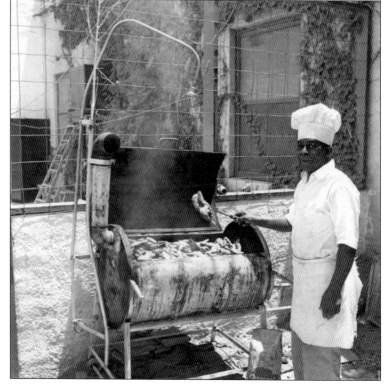

Marfa began and ended its 1983 centennial celebration with church services, a tribute to its founding fathers' efforts to establish a Christian heritage for its citizens. During the celebration, cavalry riders came to town to show how they lived in the 1880s. There was an antique show and a Pony Express rider. Kids drank sarsaparilla, and barroom pianos added to the fun as people danced and listened to concerts in historic Sunset Park. (Logo photograph by Vicente Celis.)

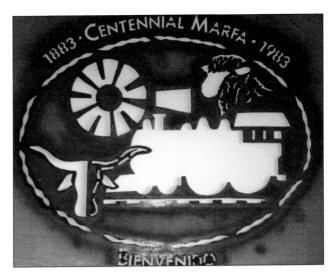

Ann Dunlap and her daughter Ariel model period clothing at the centennial fashion show while pushing son Sam in a vintage baby carriage. (Courtesy of Ann Dunlap.)

George Stevens, director of the 1955 epic *Giant*, chose the Marfa area to film "the *Gone with the Wind* of Texas." The film was an adaptation of the novel written by Edna Ferber in 1952. Stevens chose the location because of the way local cloud formations translated to the screen. The Worth Evans family ranch outside Marfa was chosen as the site for exterior scenes. The Worth Evans family poses here with director Stevens. From left to right are Clay Evans, George Stevens, Katherine Evans standing in front of her husband Worth, J. W. "Bub" Evans, Billy Ann Bunton Evans, and the youngest, Jean Ann. Worth Evans declared himself "the tiredest man in Texas" during the shooting of the film. He rode herd on the 1,238 head of cattle and 115 horses used in the film. He was heard to say, "These cattle have been worked so often they are ready for a union card." (Courtesy of Evans Collection.)

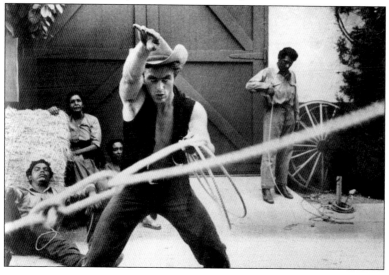

This is a rare candid photograph of James Dean as he practices roping. He practiced constantly while waiting to be called to shoot a scene. (Courtesy of Evans Collection.)

James Dean sits under a tent while rehearsing an upcoming scene from the script. He was often observed on the set employing the Method approach to acting. (Courtesy of Evans Collection.)

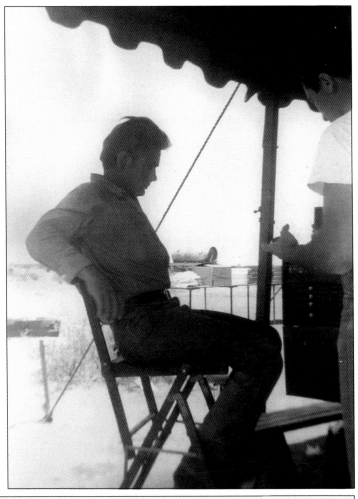

```
150.    CLOSEUP    JETT RINK

        Sitting on a rock, surveying the house, the windmill, the
        rocky ground -- his property.  In his eyes we see pride --
        the pride of a man who is now more than just a man; he is
        the sum of a man and his possessions.  Jett seems more
        interested in the quiet earth beneath him than he is in the
        creaking windmill above.  His look is fixed on the barren
        ground.  What he sees is of great importance to him, --
        perhaps green crops bursting from the earth -- perhaps a
        fence and paint and improvements -- perhaps he is looking
        far below the surface, where water lies to make this trans-
        formation possible.  Jett is a man of intuition, of keen
        instinct.  Perhaps he penetrates below the water, -- perhaps
        he senses the ocean of oil that lies beneath.  The strange
        sense of triumph that the ORCHESTRA CONVEYS leads the audience
        to sense some of this.

                                               DISSOLVE:
```

This direction to James Dean from the director, George Stevens, could have been the scene that Dean was pondering in the previous photograph. (Courtesy of Evans Collection.)

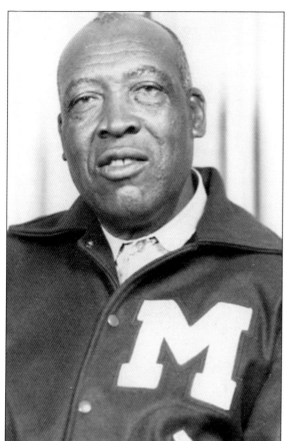

Granison Chaney was a famous face around Marfa for many years. He was the local bootblack back in the days when the ranchers and cowhands wore their boots all the time and took good care of them. Granison was an affable person and landed a role as the porter on the train in *Giant*. (Courtesy of Marfa and Presidio County Museum.)

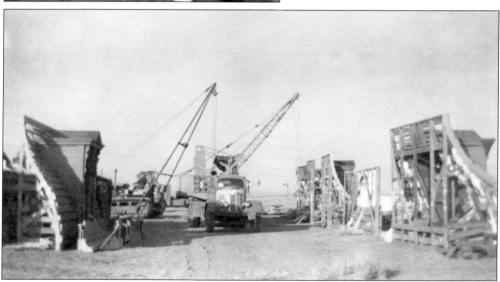

All who have seen the movie have seen the Reata mansion, but seldom has anyone seen photographs of the huge Gothic mansion being brought onto the set. It arrived in boxcars from the Warner Brothers scenery department and was installed on the Evans Ranch in a matter of days. (Courtesy of Evans Collection.)

Elizabeth Taylor takes instruction in riding on a Western saddle from the horse's handlers. Taylor was adept at riding an English saddle, but she must have required some help riding a ranch cowpony Western style. (Courtesy of Evans Collection.)

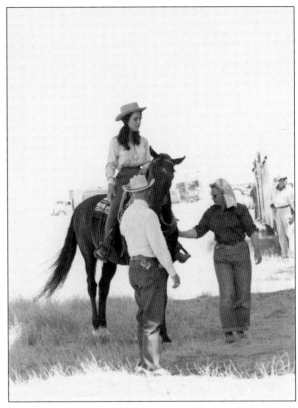

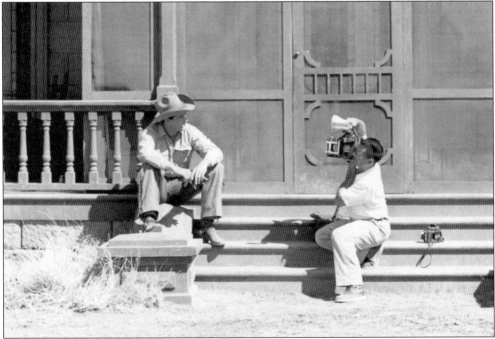

Onlookers often saw Rock Hudson on the *Giant* set with a camera in his hands, but here someone captured him outfitted in his "Bick" wardrobe. (Courtesy of Evans Collection.)

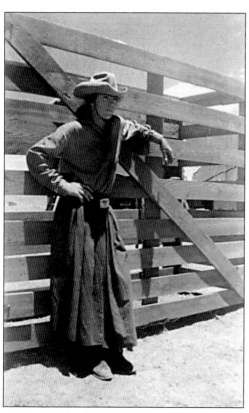

The hat worn by Mercedes McCambridge in *Giant* was given to her by Gary Cooper. (Courtesy of Evans Collection.)

Today all that is left of the Reata mansion on the Evans Ranch is a skeleton. Storms and the ravages of time have taken their toll. It is still visited by "worshipers at the shrine." Here the remains of the mansion are seen with an Aerostat balloon clearly visible behind them. (Photograph by Louise S. O'Connor.)

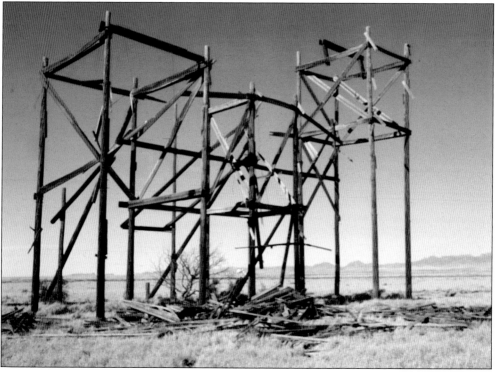

Flesh and Bone was shot in Marfa in 1993. All that is left of the Stardust Motel, where parts of the film were shot, is this sign that played a significant role in the closing minutes. The film starred Dennis Quaid and Meg Ryan. (Photograph by Louise S. O'Connor.)

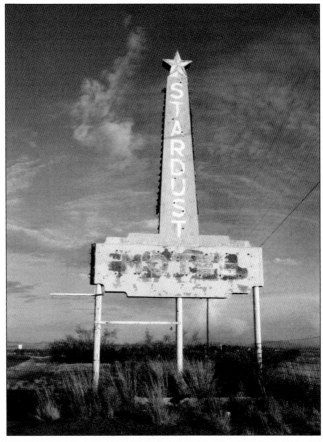

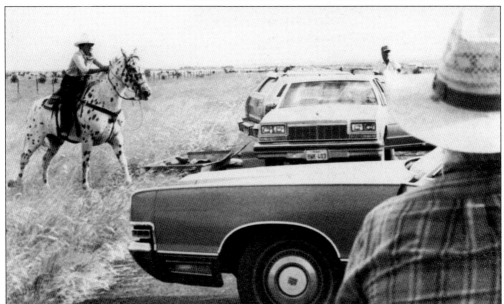

Sylvester, starring Melissa Gilbert, was made in Marfa in 1985. Here Amy Surratt, daughter of Frances and Ted Harper, stunt rides for Gilbert. (Courtesy of Harper Collection.)

Ted Harper, a local rancher, was in this scene from *Sylvester*. He was also an extra in *Andromeda Strain*, depicting the dead priest on the church steps. *Andromeda Strain*, directed by Robert Wise in 1971, was filmed around Shafter, but the movie company stayed in Marfa. (Courtesy of Harper collection; Marfa and Presidio County Museum.)

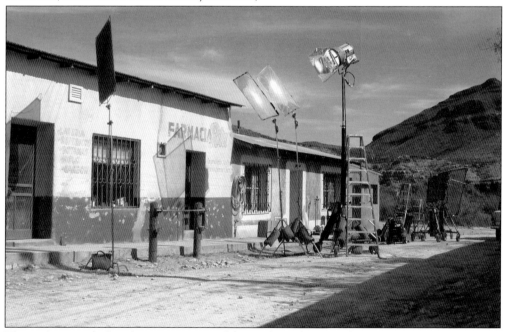

This is the setup before shooting a scene of the *Andromeda Strain*. (Courtesy Marfa and Presidio County Museum.)

Parts of the movie *Fandango* were shot in Marfa. The Love family monument was used in a poignant scene between stars Elizabeth Daily and Judd Nelson. The Love family is a local pioneering family. (Photograph by Louise S. O'Connor.)

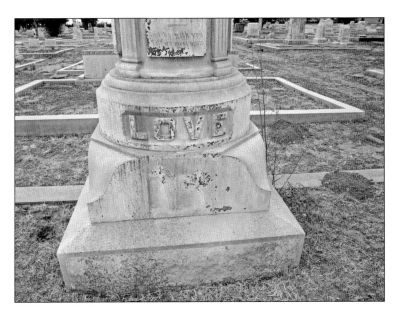

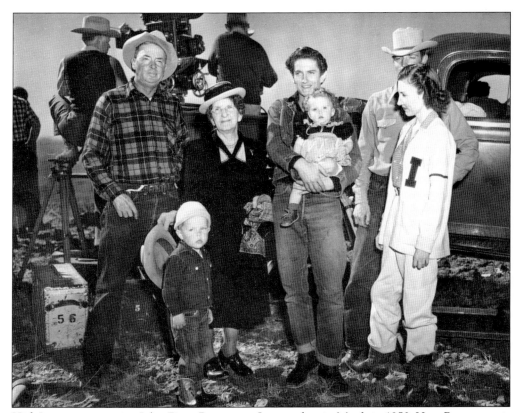

High Lonesome, starring John Drew Barrymore Jr., was shot in Marfa in 1950. Here Barrymore is seen with a Marfa notable, Mrs. Edward "Eddie" Brite. (Courtesy of Brite/White Collection.)

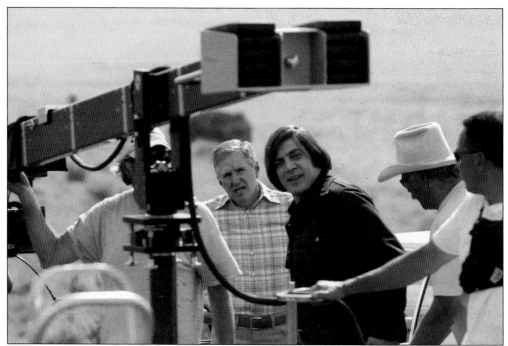

Marfa's 2008 Academy Award–winning film *No Country for Old Men* was directed by the Coen brothers. Many of the scenes depicted early in the film were shot in the vicinity of Marfa. Standing to the left of Javier Bardem is Marfa's own Chip Love, who died at Bardem's hand in the first minute of the film. (Photograph by Alberto Tomas Halpern; courtesy of *Big Bend Sentinel*.)

In this photograph, one can see the remains of the set used in the Academy Award-winning film *There Will Be Blood*, which was filmed on the MacGuire Ranch south of town in 2007. Food tents and dressing rooms were located on the neighboring Kerr Mitchell Ranch. The film starred Daniel Day Lewis, who was often seen jogging in Marfa in order to keep his slim figure. (Photograph by Alberto Tomas Halpern; courtesy of *Big Bend Sentinel*.)

Eight

THE
CONTEMPORARY SCENE
1974–PRESENT

The economic resurgence of the area via the arts is widely acknowledged to stem from artist Donald Judd's move to Marfa from New York City in 1972. The Dia Art Foundation designated Judd as director of the Dia Museum located at Fort D. A. Russell. At a later date, to avoid a lawsuit when Judd threatened to sue the Dia Art Foundation for failure to observe the terms of a contract with him, a settlement was reached and the result was the founding of the Chinati Foundation in 1986. The Chinati Foundation and the Judd Foundation have left a legacy to Marfa and the area that has brought about a cultural renaissance heretofore undreamed of in the environs of Far West Texas.

By 1997, a cultural migration to Marfa had begun, led by Houstonians Tim and Lynn Crowley, active in the state, national, and international art scene, as well as Dallas attorney Pablo Alvarado. New residents purchased and renovated various houses in Marfa for use by writers in residence who give public readings year-round. More recently, Ballroom Marfa has become world-renowned as a visual arts, film, music, and performance venue. Marfa's Goode Crowley Theater produces professional-level theatre.

As Marfa grows and thrives, more and more events occur on a weekly basis. There seems at times to be more to do than a person can find time for. The soaring meets continue, as Marfa has some of the best thermals in the world for gliders. Marfa now has a film festival, the art and cultural world attracts people from all over the world to openings and events, and people continue to visit in order to catch a glimpse of the famed Marfa Lights.

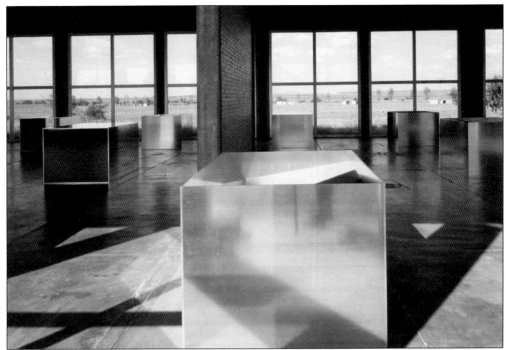

Donald Judd's *100-mil Aluminum* sculptures are permanently installed throughout two buildings, formerly Fort D. A. Russell gun sheds, at the Chinati Foundation. His large-scale concrete pieces can be seen in the background. (Courtesy of Chinati Foundation.)

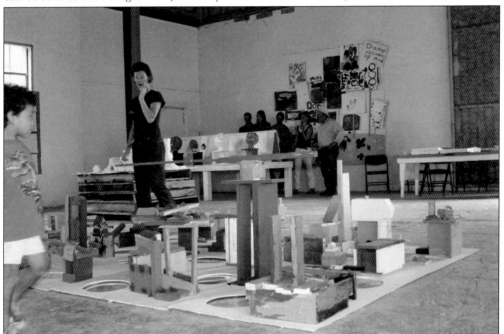

Chinati Foundation's executive director, Marianne Stockebrand, surveys artwork created by community youth through the foundation's annual summer art program for children. (Courtesy of Chinati Foundation.)

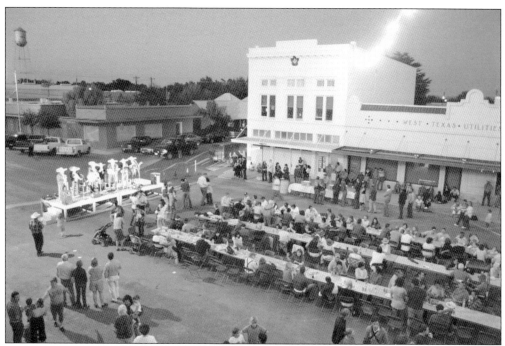

Each fall, the Judd Foundation partners with the Chinati Foundation to sponsor an open-house weekend that attracts thousands of art lovers to Marfa. As part of the 2006 events, visitors and community members mingle for dinner and enjoy mariachi music on Highland Avenue. (Photograph by Fred Covarrubias Jr.; courtesy of *Big Bend Sentinel*.)

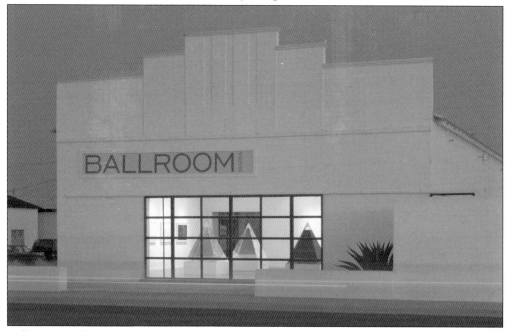

Ballroom Marfa was founded in 2003 by Virginia Lebermann and Fairfax Dorn as an art and cultural space. It offers educational programming, art exhibitions, and numerous music, film, dance, and performance presentations each year. (Courtesy of Ballroom Marfa.)

In a unique collaboration between Ballroom Marfa and Michael Meredith, a Harvard professor of architecture, the first drive-in cinema built by an American nonprofit organization will offer townspeople and visitors the opportunity to see movies under the stars as many of the older generations once did. (Courtesy of Ballroom Marfa.)

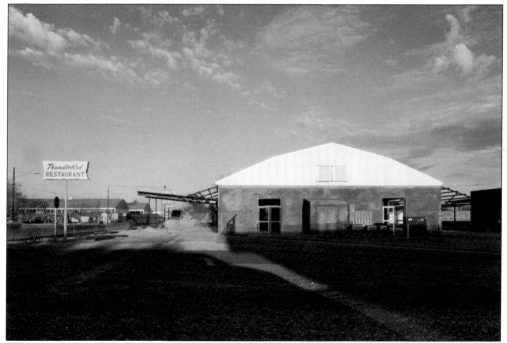

Renovations are taking place in Marfa daily. Here the old Thunderbird Restaurant and Holiday Capri Motel are being prepared to become a performance venue and restaurant. The old Thunderbird Restaurant was once one of the main gathering places for the town. (Photograph by Louise S. O'Connor.)

The renovated Liberty Hall (Teatro Libertad) is a popular performance venue that was originally a theater for Spanish-speaking movies and performances. It was constructed in 1919 by the Mendias family of Marfa. (Courtesy of Ballroom Marfa.)

The Lannan Foundation's residency program offers uninterrupted creative time to exceptional writers who are invited to live for up to three months in one of five specially designed Lannan-owned homes in Marfa. Peter Reading was the first Lannan Foundation writer in residence in Marfa in 1998. He is pictured here with his wife, Deborah. (Courtesy of Lannan Foundation.)

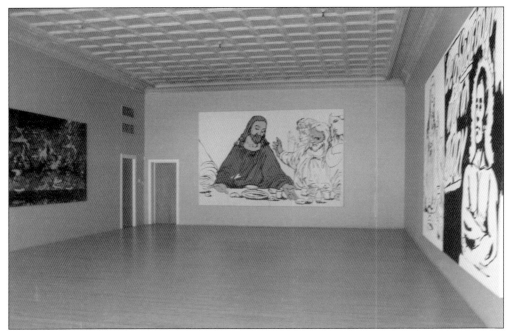

The Ayn Foundation supports the long-term exhibition of Andy Warhol's Last Supper series and work by Maria Zerres in two renovated Highland Avenue galleries on the ground floor of the historic Brite Building. Immediately adjacent, the Highland Gallery is dedicated to the exhibition of fine-arts photography. (Photograph by Vicente Celis.)

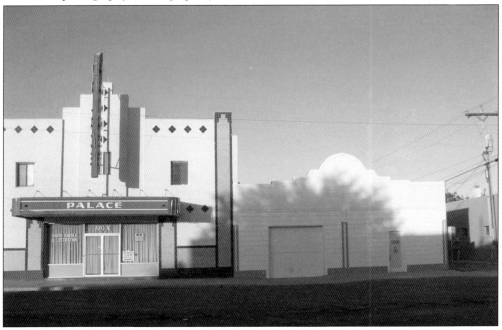

Eugene Binder opened his gallery shortly after 9/11 in the Brite Building, relocating it into a renovated garage on Highland Avenue in 2004. Graphic artist David Kimble has a studio located in the old Palace Theater next door. The Palace Theater sits on the original site of the Marfa Opera House, built in the 1890s. (Photograph by Vicente Celis.)

A John Robert Craft cast-iron sculpture and a large monoprint, made using the sculpture as a tool in the printing process, are shown at Exhibitions 2-d. The contemporary gallery is located on South Highland Avenue in an historic adobe house originally constructed around 1890 and fully renovated by owner Dennis Dickinson in 2003. (Courtesy of Dennis Dickinson.)

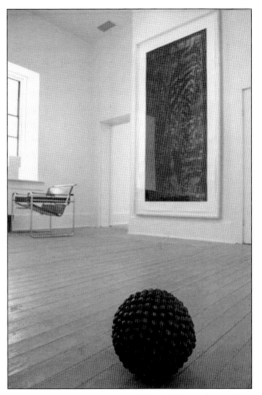

Gallery owner Ree Willaford represents a variety of contemporary artists at Galleri Urbane, located on Highway 90. The Inde/Jacobs Gallery, situated between Galleri Urbane and Ballroom Marfa, features the work of artists associated with the Chinati Foundation plus selected emerging and mid-career artists. (Photograph by Vicente Celis.)

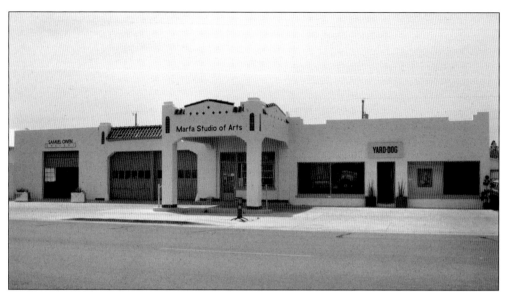

The Samuel Owen Gallery, exhibiting vintage posters; Marfa Studio of Arts, a local nonprofit arts organization; and Yard Dog Gallery, featuring contemporary folk art, share space in a renovated garage and filling station located on Highway 90. (Photograph by Vicente Celis.)

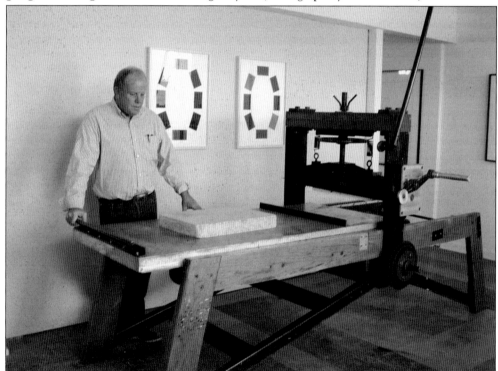

Robert Arber prepares a litho stone at Arber + Son Editions, located on East El Paso Street. Installed behind Robert are two Valerie Arber prints from her Pearl series. The building was previously a movie theater, skating rink, and electronics store before its current reincarnation as a sophisticated printing studio and artist living loft. (Photograph by Alberto Tomas Halpern; courtesy *Big Bend Sentinel*.)

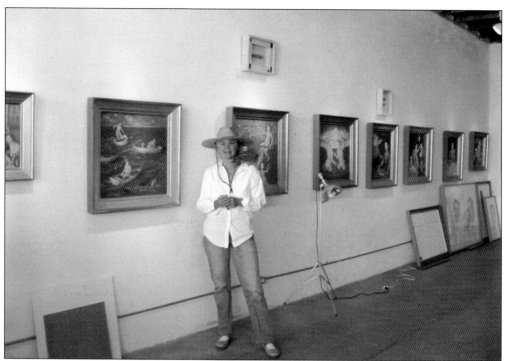

Artist Julie Speed works in her East El Paso Street studio, one of many artist studios and exhibition spaces that now dot the historic street. El Paso Street has been a crossroad of Marfa commerce since the beginning of the 20th century. (Photograph by Vicente Celis.)

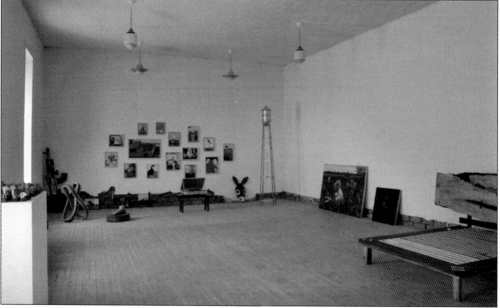

The chapel of Marfa's first church, San Pablo, constructed in 1886, is currently used as a part-time gallery and studio by woodworker and artist Campbell Bosworth. Work shown in this photograph was exhibited in a show at the Janette Kennedy Gallery in Dallas, Texas, in May of 2008. (Photograph by Louise S. O'Connor.)

Artist Charles Mary Kubricht and her husband, attorney Ron Sommers, established a home in Marfa as part of Marfa's "New Wave" in 1998. In her studio, Kubricht conceptually explores topics such as the cataloging of a visual vocabulary of landscape, while Sommers lends his legal expertise to nonprofit institutions such as the Trans-Pecos Water Trust and the Marfa Public Library. (Photograph by Vicente Celis.)

Painters Maryam Amiryani and Nick Terry are pictured with Dersu in front of their duplex-style studio, constructed in 2005. (Photograph by Vicente Celis.)

Thornton Wilder's American classic, *Our Town*, directed by Cecilia Thompson, was produced in 2002 at the Goode Crowley Theater. A diverse cast of 30 included actors from Marfa and neighboring towns Fort Davis and Alpine. Here Fritz Kahl studies his lines for his scene. (Courtesy of Mrs. Georgie Lee Kahl.)

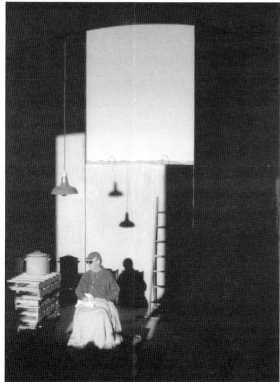

Samuel Beckett's *Endgame* was directed by Andre Gregory in 2005 in the Judd-designed concrete buildings that are part of the Chinati Foundation and overlook Pinto Canyon Road. (Courtesy of Rob Weiner.)

The King Slept Here, directed by Marfa's Rob Weiner, was one of playwright Suzan-Lori Parks's 365 Days/365 Plays produced in 2007 at the Goode Crowley Theater. (Courtesy of Rob Weiner.)

The multifaceted and talented Jo Harvey Allen and Terry Allen frequently perform at various Marfa venues. Jo Harvey, a widely recognized actress, writer, and artist, and Terry, an artist and musician, make their home in Santa Fe, New Mexico, and Marfa, Texas. (Courtesy of Ballroom Marfa.)

An array of local talent performs in the annual variety show known as the Pachanga (a slang word derived from Spanish meaning "a party or a bash"). The event is produced by the Marfa Theater/Marfa Live Arts. (Courtesy of Marfa Theater/Marfa Live Arts.)

A leading exponent of contemporary music, Bruce Levingston enthralled audience members as he performed classical works on a Steinway grand piano at the Goode Crowley Theater in October of 2007 in a concert sponsored by Ballroom Marfa. Levingston has premiered numerous works at Carnegie Hall and Lincoln Center and has appeared in concerts and recitals throughout the world. (Courtesy of Ballroom Marfa.)

Marfa resident Nina Martin is an internationally recognized dancer and choreographer bringing postmodern performance and dance to Marfa since 2001. Martin's dance ensembles are often accompanied by recorded sound and music composed by Paul Hunt. (Photograph by Jeffrey Brown; courtesy of Nina Martin.)

Noted lounge singer Jackie Pepper, with composer/musician Adam Bork, amazed and delighted sold-out audiences in December of 2007 in performances that benefited the Marfa Community Health Clinic. (Courtesy of Vance Knowles.)

The Friends of Marfa Public Library received a prestigious National Endowment for the Arts grant, which was supplemented by local contributors and the Lannan Foundation, to fund Marfa's The Big Read project. Hundreds of copies of the novel *Bless Me, Ultima* by Rudolfo Anaya, printed in both Spanish and English, were distributed to community members and high school students. More than 30 The Big Read events and discussions held during February of 2008 were planned and coordinated by Alice Jennings, president of The Friends. (Photograph by Fred Covarrubias Jr.; courtesy of Ballroom Marfa and Friends of Marfa Public Library.)

Video artist Jennifer Lane conducts a portfolio review with a sixth-grade student as part of the Studio in the Elementary School (SITES) program, founded in 2005 by artists Ellie Meyer-Madrid and Malinda Beeman of Marfa Studio of Arts (MSA) in order to provide visual arts experiences to all children in the Marfa Elementary School. (Photograph by Vicente Celis; courtesy of MSA/SITES.)

Marfa resident Karen Bernstein is well known for her work in documentary film and video production. She was series producer for PBS's acclaimed American Masters series, for which she received a Primetime Emmy and a Grammy Award for documentaries on Ella Fitzgerald and Lou Reed, respectively. Bernstein is currently working on a documentary related to Marfa's Blackwell School, which at one time served Marfa's Hispanic schoolchildren. (Photograph by Vicente Celis.)

Joe Cabezuela, president of the Blackwell School Alliance, discusses plans to restore Blackwell School to its original state in order to establish it as a local museum. It will honor longtime principal Jesse Blackwell and the Hispanic students who attended the school, which closed in 1964, marking the official integration of all public schools in Marfa. (Photograph by Louise S. O'Connor.)

Village Farms cultivates over 120 acres of
hydroponic tomatoes in greenhouses on
the outskirts of Marfa to the north. A more
recent addition to local agriculture is the
Luz de Estrella Winery, located 3 miles
east of Marfa on Highway 90, surrounded
by spectacular desert mountain ranges.
(Photograph by Sterry Butcher; courtesy of
Big Bend Sentinel.)

Don Culbertson and his son Victor purchase
fresh vegetables and artisanal baked
goods from Sandra Harper, one of many
community members who have contributed
to the success of Farmstand Marfa. The
outdoor market takes place under the
"Pole Shed" and offers homegrown organic
produce for sale on Saturday mornings.
(Photograph by Erica Blumenfield; courtesy
of Farmstand Marfa.)

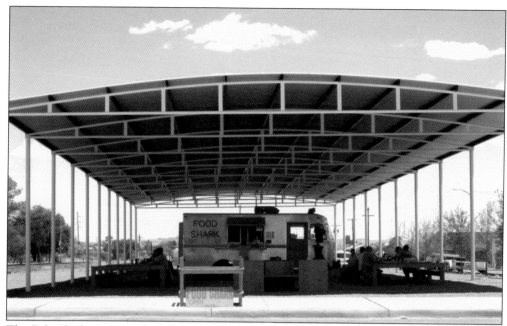

The Pole Shed structure, built by Marfa resident Tim Crowley for community use, shades the Food Shark, a unique mobile restaurant that serves Middle Eastern cuisine prepared by proprietors Krista Steinhauser and Adam Bork. Judd-designed furniture built by Randy Sanchez of the Judd Foundation provides a public seating area. (Photograph by Vicente Celis.)

A redesigned 1940s service station is home to the Blue Javelina, a restaurant whose dining room features a table that is the original garage's 14-foot truck lift capped by two slabs of clear acrylic. (Photograph by Vicente Celis.)

The Austin Street Café is located in an historic adobe home known locally as the "Walker House," which was renovated by owners Lisa and Jack Copeland. It is situated on a quiet residential corner a few blocks west of the courthouse. (Photograph by Vicente Celis.)

Maiya Keck and her husband, Joey Benton, the restaurant's designer, opened Marfa's first upscale restaurant in 2002 as part of Marfa's renaissance as an art community. The couple recently opened the Get Go, a natural food and gourmet grocery housed in an early-20th-century building south of Highway 90 on Dean Street. (Photograph by Vicente Celis.)

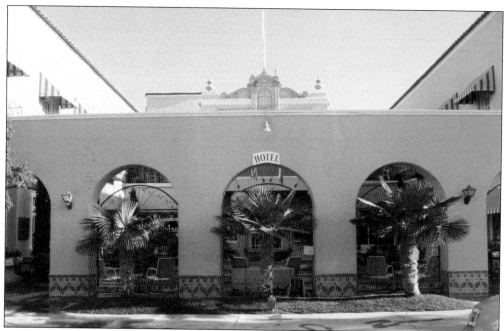

Jett's Grill, located in the historic El Paisano Hotel, offers both a formal indoor dining area and casual dining in a courtyard that is surrounded by a number of boutiques and the Greasewood Galleries. The hotel also houses a permanent exhibition of *Giant* memorabilia and photographs of *Giant* cast members James Dean and Elizabeth Taylor, among others. (Photograph by Vicente Celis.)

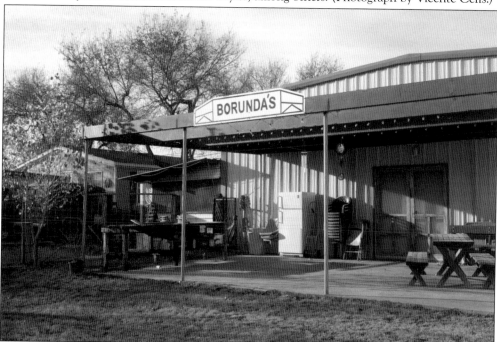

The owners of Borunda's Bar and Grill, Judy and Pancho Borunda, inherited recipes from Pancho's aunt, Carolina Borunda Humphris, who operated the first Tex-Mex restaurant in Texas, the original Borunda Café. (Photograph by Vicente Celis.)

Cochineal, operated by Tom Rapp and Toshifumi "Toshi" Sakihara, offers fine food featuring traditional ingredients prepared in a decidedly gourmet fashion. Fresh greens and herbs used in Toshi's dishes are organically grown in the Cochineal gardens by Toshi. (Photograph by Vicente Celis.)

Located across from the Presidio County Courthouse, the eclectic Squeeze Marfa offers a limited soup and sandwich menu, a variety of fruit and vegetable smoothies, and exquisite imported Swiss chocolate. (Photograph by Vicente Celis.)

The Dairy Queen, an iconic small-town institution, remains a local gathering spot for coffee, ice cream, and camaraderie for all. (Photograph by Vicente Celis.)

Amidst the many arts and cultural foundations located in Marfa, the Pizza Foundation, opened by Saarin Keck and Ronnie O'Donnell in 2003, offers the most authentic pizza in the area. It is located in a former filling station that stands where the Marfa Manufacturing Company once stood at the intersection of Highway 90 and Highland Avenue. (Photograph by Vicente Celis.)

The Marfa Book Company was opened in 1999 by Lynn and Tim Crowley as one of the first and most important small-business ventures in Marfa as the town came back to life at the outset of the new millennium. Today it offers customers a comprehensive selection of art and architecture books. Artists residing in Marfa, including Christine Olejniczak, Michael Roch, and Craig Rember, among many others, have exhibited work in the gallery. The Shortstop, serving beverages of all kinds, and Marfa Public Radio, an affiliate of National Public Radio, are also located in the building that was first operated as the Jordan Hotel and later as the St. George Hotel. (Photograph by Vicente Celis.)

Once the W. B. Mitchell home, this historic house remained in the family for three generations before being sold to attorney Pablo Alvarado Jr. of Marfa and Dallas, who refurbished it in the 1990s. (Photograph by Vicente Celis.)

Originally the Baygent Bus Station, this home has undergone several renovations through the years. Now owned by Shelly and Harry Hudson, it currently includes a guesthouse and indoor lap pool as well as a private residence enclosed by a unique adobe wall. (Photograph by Louise S. O'Connor.)

Prominent Houston attorney Dick DeGuerin and his wife, Janie, purchased this property as part of the Marfa renaissance at the urging of Lynn and Tim Crowley, with whom they were professionally and socially connected. The DeGuerins totally renovated the interior and added patios and porches for outside dining. Three Kiva-style fireplaces were also added. (Photograph by Louise S. O'Connor.)

This house is the renovation of what appears to have been a military barracks at one time. According to a map found at the Texas Historical Association in Austin, the structure was in existence in the 1890s. (Photograph by Vicente Celis.)

The Marfa Sector of the U.S. Border Patrol is responsible for immigration control in 77 West Texas counties and 18 counties in Oklahoma—a total of 92,000 square miles and 365 miles of border. The drug interdiction program is also a major focus of Border Patrol activity in the Marfa Sector. (Photograph by Louise S. O'Connor.)

Retired U.S. Border Patrol agent Gary de Cocq poses with his drug-sniffing dog Doerak in this photograph. Doerak always accompanied Gary as he made his drug-busting rounds. Sadly Doerak died far too young, at age two, from a heart attack. (Courtesy of Gary de Cocq.)

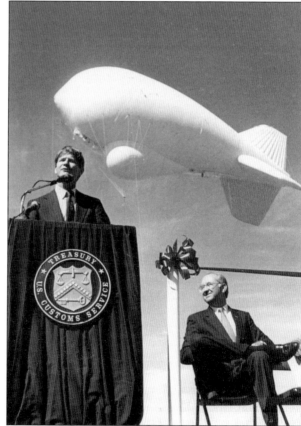

Republican senator from Texas Phil Gramm attended the dedication ceremony of the Aerostat balloon facility 15 miles west of Marfa in 1989. Aerostat facilities are part of an attempt by the federal government to stem the smuggling of drugs across the border. (Photograph by Robert Halpern; courtesy of *Big Bend Sentinel*.)

Demonstrations on the courthouse lawn against the state's attempt to locate a radioactive waste disposal site in Sierra Blanca were frequent throughout the middle and late 1990s. Marfa resident Gary Oliver, among others, was instrumental in successfully blocking the Texas Low-Level Radioactive Waste Disposal Authority. (Photograph by Robert Halpern; courtesy of *Big Bend Sentinel*.)

La Entrada al Pacifico, a NAFTA trade route signed into law by then governor George W. Bush in 1997, will significantly increase the number of long-haul trucks bringing goods from Mexico through Marfa. Marfa resident John Wotowicz has spoken eloquently against La Entrada, rallying citizens to protest and post signs along the proposed La Entrada route. (Photograph by Louise S. O'Connor.)

Marfa's El Paisano Hotel was the site for a January 2008 protest against the federal government's proposal to build a wall along the U.S./Mexico border in South Presidio County. Opponents argue that the wall will not make the United States safer or solve immigration issues but will cause damage to the borderlands politically and ecologically. (Photograph by Fred Covarrubias Jr.; courtesy of *Big Bend Sentinel*.)

Once threatened, falcons are being reintroduced throughout the area surrounding Marfa. (Courtesy of Christina Kleberg.)

The first recorded viewing of the Marfa Lights phenomenon was by Robert Ellison around 1880. The nocturnal lights are often described as colored spheres that dart along the horizon, sometimes splitting or suddenly rising or falling without explanation. (Photograph by James Bunnell, ©2004.)

The Texas Department of Transportation built the Marfa Lights Viewing Site 9 miles east of Marfa. The structure's design was based on plans developed by Marfa High School students led by Gifted-Talented Specialist teacher Felicia Martinez. (Photograph by Louise S. O'Connor.)

Like all small towns, Marfa loves a parade. Each year, the Marfa Lights Festival, sponsored by the local chamber of commerce, kicks off the annual Labor Day celebration with a parade down Highland Avenue, and the Marfa Independent School District sponsors the fall homecoming parade. (Courtesy of *Big Bend Sentinel*.)

Watch out for Marfa's next generation. It is ready, willing, and able. (Photograph by Vicente Celis.)

EPILOGUE

This is pioneering, frontier country to this day. The young people coming out here have gumption and a motivation to once again pioneer this area. They are looking for a place to go. Their old worlds are worn out and going nowhere, so they drift west once again, as so many people before them have done.

ACROSS AMERICA, PEOPLE ARE DISCOVERING SOMETHING WONDERFUL. THEIR HERITAGE.

Arcadia Publishing is the leading local history publisher in the United States. With more than 4,000 titles in print and hundreds of new titles released every year, Arcadia has extensive specialized experience chronicling the history of communities and celebrating America's hidden stories, bringing to life the people, places, and events from the past. To discover the history of other communities across the nation, please visit:

www.arcadiapublishing.com

Customized search tools allow you to find regional history books about the town where you grew up, the cities where your friends and family live, the town where your parents met, or even that retirement spot you've been dreaming about.

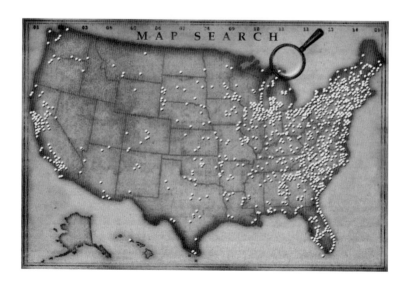